seeing beyond sight ⌐

seeing beyond sight

photographs by blind teenagers

TONY DEIFELL / FOREWORD BY ROBERT COLES

CHRONICLE BOOKS
SAN FRANCISCO

Library of Congress
Cataloging-in-Publication Data
available.
ISBN-10: 0-8118-5349-7
ISBN-13: 978-0-8118-5349-1

Manufactured in Singapore.

Design by JULIA FLAGG
Photographs printed by IRIS DAVIS

Original framing of images
maintained everywhere possible.

Distributed in Canada by Raincoast Books
9050 Shaughnessy Street
Vancouver, British Columbia V6P 6E5

10 9 8 7 6 5 4 3 2 1

Chronicle Books LLC
680 Second Street
San Francisco, California 94107

www.chroniclebooks.com
www.seeingbeyondsight.com

contents

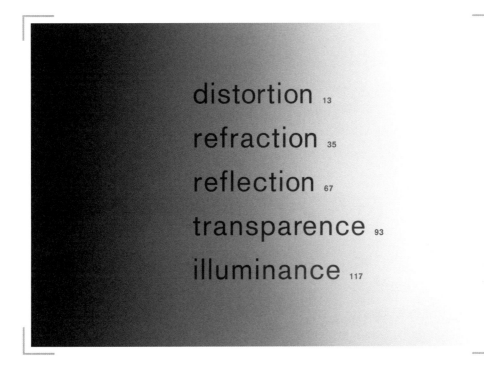

Raymond Carver's great story "Cathedral" treats of a trio—a middle-aged couple and a visitor who comes to spend a holiday with them, and the visitor's blind. Out of this threesome (the subtleties of their carryings-on, the shifts in their attitudes and allegiances) a writer has wrought a powerfully instructive moral fable, culminating in an extraordinary scene wherein the blind man and his host, the husband, who has earlier on been resentful of (unable to fathom) his wife's interest in—friendship with—this stranger, now become engaged in drawing a cathedral together. (They are watching—hearing—a television program that tells of the medieval age, and the construction of such giant churches over the decades, the generations.) Soon enough, it is for them a matter of hand on hand, a wondrously affecting shared effort: an expedition or pilgrimage, really, into an understanding that links these individuals, as in Nietzsche's "it takes two to make a truth." One does not impart knowledge, the other receive it; now it is "the blind leading the blind"—the leveling of their common humanity, with plenty of "darkness" and limitation for each to bear as a burden, but less so in the other's trusted company.

"Blinded, you fall into darkness, and you're dead"—a statement that pushes things to the limit. So a high school student of mine aimed to do when he spoke those words, he who had 20/20 vision, and prized his powerful body in a neighborhood where he needed every ounce of strength he had, and an eagle-eyed vision, too. "Without my eyes working overtime, I'm a goner," he once pointed out. And then he amplified: "I'd not know what I need to know—*everything!* A guy who wanted to knock me out and not face a murder rap, he'd go for my eyes!" So it went, too, in Sophocles' time: you could get to know "everything," but still you were in line for the biggest trouble possible, short of death. And so Oedipus lost his eyesight—a living death, of sorts, for him, as for a contemporary youth. Yet the Hebrew prophets and Jesus, who strongly espoused their ethics, knew irony, and allowed for forgiveness, a redemptive turn in things. As a consequence, blindness moved from being a terrible curse inflicted on the worst of the worst—those who violate (through acquired knowledge) the most important psychological and moral taboos—to an aspect of our waywardness, our flawed condition, that is around any corner for any of us to meet, come to experience. Under these terms of our personal, our *spiritual* condition, we have enough in common with any outcasts to warrant a tragic guardedness when we consider them— as in the self-admonition, "there but for the grace of God go I."

Today, in a secular society, we speak of the unconscious, that great leveler, as every single person's repository of all crimes, huge or relatively minor, from incest and murder to a laziness that falls short of sloth, or a silent envy that never becomes enacted greed. For Carver, "Cathedral" was a means of evoking a topsy-turvy Judeo-Christian tradition that warned against moral or psychological self-assurance—a sure prelude to smugness. Christ's closeness to the "despised and scorned" becomes the story of a heretofore callous American "Joe" who (at the end of this quite plain and funny, but also brilliantly plotted, wondrously narrated short fiction) has turned into a near-Tolstoyan sojourner, almost within grasp of a transcendent wisdom, all courtesy of a plain, unaffected blind man whose greatest virtue, courtesy of his creator, is to be thoroughly earthy, a bit naive, and only reluctantly a touch didactic— at his best, an accidental moment's spiritual journeyman, only half-awake to the mission of sorts that has befallen him, rather than been sought by him.

I settle for Raymond Carver's vision, his view, his insight— calling up all those eye-connected words, even as "eye" and "I" are indistinguishable to our ears except in the context of a sentence, a statement; and it is context that matters, says Carver, in the course of fulfilling the modest anecdotal calling of the storyteller. To be literally blind is far from fun, no question, but to be blind to others in the subjective or moral sense is a darkness all its own.

So it is with all of us as we consider those who can see, literally, and those who cannot fully see, yet manage to take the world's measure, figure it out, make much out of what is available to them. How well I remember my days as a pediatrician in training—taking note of children who had lost some of their vision, but who managed to pull together what they had seen; figure it all out tellingly; and, in so doing, affirm their humanity. We are the creature who pulls things together, tries to get the larger sense of what happens around us, finds meaning and purpose in fragments which become, in their way, complete signs and symbols. What follows, then, are witnesses to the truth that a gifted American storyteller offered us, and the truth that our children can find for themselves, for us, and—very importantly—the truth that Tony Deifell's work helps us appreciate, comprehend, and, yes, see.

introduction
by TONY DEIFELL

When I first saw the photographs of the sidewalk, I thought they were a mistake. Perhaps LEUWYNDA had intended to capture a classmate or one of the large oak trees scattered across the campus. I was wrong. As soon as LEUWYNDA got her camera, she knew what she wanted to do: photograph the cracks in the sidewalk.

The pictures were proof of damage, and she sent them, along with a letter, to Superintendent Sheila Breitweiser. "Since you are sighted," LEUWYNDA wrote, "you may not notice these cracks. They are a big problem since my white cane gets stuck." LEUWYNDA asked that the cracks be fixed—and they were.

Photography wasn't the most obvious subject to teach at the Governor Morehead School for the Blind in Raleigh, North Carolina. Even JACKIE, one of the first students to take the class, was incredulous: "What are you thinking, teaching photography to blind people?" The project was a leap in the dark for me, and the contradictory notion was a good enough reason to jump in. Anytime there's an obvious way to do something, that's reason enough for me to try a completely different way.

A deeper reason also compelled me. **As a photographer, I have always feared losing my eyes, and I began to wonder, "If I were blind, could I still make photographs?"** Even if I were not a photographer, I would still, like so much of the world, be dependent on sight. I assumed that losing my eyesight would mean being lost in the world. As John Berger put it in his book *Ways of Seeing,* "It is seeing which establishes our place in the surrounding world."

A rabbi once told me that the Talmud refers to people who are blind as *sagi nahor,* Aramaic words that mean "great eyesight." As the rabbi explained, perhaps people who are blind see more than those who are sighted; perhaps there is seeing beyond sight. As the son of a preacher, I have been predisposed to mystical interpretations most of my life, so this paradox affirmed an intuition I had about these unlikely photographers.

The idea came in 1991, after hearing a public radio show about Henry Butler, a New Orleans jazz legend who is blind and takes pictures. About the same time I was volunteering with a project at the Center for Documentary Studies at Duke University with photographer Wendy Ewald, who taught children to take pictures so that she could understand their view of the world. I wondered, **"What would children who are blind show us about the world, if they learned to take pictures?"**

When I first called Governor Morehead School in early 1992, outreach director Joan Baker was suspicious, thought maybe I was pulling a prank. Persistence paid off. She eventually took me seriously and agreed to oversee an experimental after-school "photography club."

I felt uncomfortable for the first few weeks, awkwardly side-stepping such common sayings as "*see* you later" or "do you *see* what I'm talking about?" The school was a different world. Everywhere I looked, I saw students slouching, with their heads halfway in their laps. Since they didn't need to look at people, they didn't need to sit up straight. This was unsettling because it appeared that no one was listening. I was new to teaching and couldn't imagine anything worse than students not paying attention—it made me wonder what I was doing there in the first place. Then one day as I rushed into the classroom and spilled my notebook and bags onto the table, a student asked, "That you, Mr. Deifell?" The sound of my bustling had become familiar. They had been paying attention all along, aiming their ears at me instead of their eyes.

Three students had signed up for the first session: JACKIE, DEAN, and JOHN. I didn't know how to get started any more than they did. The cameras were point-and-shoot, so their challenge lay mostly in where to point them. The students would ask questions about their surroundings, feel their subjects with their hands, and listen carefully to the hush and noise around them. It was as if they were listening for "sound shadows," a term that became the name of our project, inspired by a memoir about growing up blind by Ved Mehta, longtime writer for the *New Yorker.*

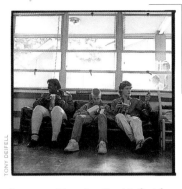

JACKIE, DEAN, and JOHN
(left to right) **open their camera boxes during the first day of class in 1992.**

The project got off to a slow start. After shooting his first few rolls of film, DEAN decided he just didn't like taking pictures and dropped out. **I wondered if photography would only serve to make students feel bad about their disability, and I began to question the whole endeavor.** The project's future came to rest entirely on JACKIE and JOHN. I hoped that one of them would find an irrefutable reason for learning photography, so I could show administrators why it was so important to teach photography at the school.

When it came down to it, JOHN just wanted to take pictures of his girlfriend, WENDY. His first rolls came back loaded with her image. WENDY in the cafeteria. WENDY in the classroom. WENDY in the residence hall. WENDY at the state fair. He gave prints of these photos to his parents, showed them to all his teachers, and carried them in his backpack everywhere he went.

At the time, I was worried that JOHN's choice of subject didn't demonstrate the pedagogical importance of our photography endeavor. Looking back, I realize the significance of his choice. His parents lived two hours away on the North Carolina coast, and they didn't know what their son's girlfriend looked like. By using a camera, JOHN was able to show them. Then he proceeded to show everyone who was sighted—something he couldn't have done if he had only used a Braille Writer.

JOHN probably had many reasons for wanting to capture WENDY on film. Years later, I read about blind photographer Evgen Bavcar. He was the same age as JOHN when he first used a camera, and he also used it to photograph his girlfriend. "The joy I felt at the time came from having stolen and captured on film something that didn't belong to me. **It was the secret discovery of being able to possess something I couldn't look at,"** he recalled.

As it turned out, when other students heard that JACKIE and JOHN had cameras, they wanted in on the action. The program continued growing in popularity, and teacher Shirley Hand incorporated it into her English class. By 1997, thirty-six students had learned to take pictures. A third were totally blind, while the others had a range of visual impairments (see page 149).

Students found their own reasons for taking pictures in a world that doesn't expect them to communicate visually. TAMEKA snuck pictures of naked people and blamed it on the fact that she couldn't see. DAIN captured his favorite John Deere tractor on film, so he could carry the tractor around with him. TRAVIS, a white student who referred to himself as black, took a self-portrait and captioned it: "This is a picture of my *real* face." Perhaps these students also wanted to *possess something they couldn't look at*— to capture on film something that didn't belong to them.

· · ·

When the first pictures came back from J. W. Photo Labs, I must admit that I was disappointed. I found myself looking for something particular, for something that resembled what I had grown accustomed to seeing in photography. But all I saw were missed opportunities: heads cut off, out-of-focus images, and photos of odds and ends that seemed to be a waste of our limited film supply.

Over time, though, I came to see the images differently. I found that looking at the students' photographs and reading their captions was like listening to someone who has recently learned a new language and speaks with surprising originality in her choice of words and unwitting candor. ANTONIO photographed four one-dollar bills on his grandmother's bed and captioned it: "I wanted a picture of all my money. I thought it was more than four dollars."

The more I returned to the photographs, the more I could see in them; there were always more layers to uncover. Looking at REBA's self-portrait in the rearview mirror (page 68), I recalled making just such a picture when learning photography. It was an

obvious picture to take. Then when I thought about this picture in light of REBA's visual impairment, I realized that it might not have occurred to her as readily to use the rearview mirror instead of pointing the camera at herself, as most of the students had done. After enlarging the picture, I was delighted to find an unintended detail: the tiny words, "Objects in mirror are closer than they appear." I see that message all the time—it is on every passenger-side mirror—yet I usually filter it out. Much later, it struck me, in a new way, what this meant about seeing: **the mirror, like our minds, distorts our vision of the world.**

I started teaching photography with the assumption that everything about eyesight was good. By the second year, I wasn't so sure. Each week, a student-teacher pair would guide each other through a batch of photographs. Fellow teachers and I would describe the details of every image. Our words were their eyes. Students would tell us what they intended to capture and describe their picture-taking experience. Inevitably, we had our own judgments about what looked good in a picture. If we didn't volunteer our opinion, the students would usually ask for it. This process of "seeing" for them began to raise questions that troubled me.

For instance, when JOHN first showed us the photographs of his girlfriend, WENDY, he asked, "Does she look good?" How can you tell a person who is blind what "looks good"? How can you tell *anyone* what looks good? Just as the camera enabled JOHN to show his parents what WENDY looked like, it also equipped him to seek judgment on her beauty using criteria that were not his own. JOHN, like any American teenager, was concerned with fitting in, and he knew that people judge each other by appearances. **With a camera, he had more currency for engaging in this game.** I faced a crossroads: play the game, or say looks don't matter.

I played along—everyone did. "She's got a very cute smile," a volunteer offered. As much as I wanted to tell JOHN that looks aren't important, that's just not true: they *are* for the sighted world. That's one reason that my colleagues reminded students to stop slouching and sit up straight to face people who are speaking; it's preparation for the real world, like learning to dress for a job. Since slouching was a pose of attention for the students, they didn't need to sit up straight for themselves—they did it for the sighted world. Similarly, JOHN didn't need WENDY to be beautiful by his standards—he wanted the sighted world to see her as beautiful.

Before this project, I had mostly stereotypical experiences of people who are blind—a cane tapping the ground, dark Ray Charles glasses hiding their eyes. They appeared to be isolated in their own world, if simply because I could stare at them from a distance and they wouldn't know. As soon as I started teaching at Governor Morehead School, my view changed. Students rarely wore shades. They weren't hiding anything; they were just being themselves. Relationships replaced my stereotypes, and the students and I could see each other more clearly. Each time I look at their self-portraits, the students stare at me as much as I am staring at them, as if to remind me that sight can get in the way of seeing.

Photography, it would seem, is all about looks. But the best photographs are great because of what does not appear— leading our imaginations to recruit us as participants. At first, I offered students guidelines in an attempt to make their pictures "look good": Hold the camera level. Don't cut off anyone's head. Make sure the sun is behind you. If you're too close, the picture will blur. Despite my best intentions, the students took the most compelling images when they ignored the conventional rules of picture taking and just took the photo they wanted. Such images drew me in with clues about what was hidden just outside the frame, in the shadows, a moment before or after the shutter snapped, or in the unknown intentions of the photographer. My guidelines limited the students to capturing only the most obvious images, instead of evoking more from their picture-taking experiences.

I was nine when I took my first picture. A family friend lent me his camera during a visit to a botanical garden. I had permission to take a single shot, and eventually I settled on the idea of a

bumblebee. I waited for just the right moment, but as I pressed the button, the bee was gone. I was devastated. After the pictures were developed, my parents pointed out the beautiful flower I had captured. I still depend on luck when taking photographs. In fact, **serendipity is a crucial ingredient, as is an openness to others' insight.** Often, I need a teacher or curator to recognize an unforeseen element— such as the message in REBA's rearview mirror— that adds meaning to one of my photographs.

Once JOHN showed us a picture of a shrimp boat so far in the distance that we thought it was only a picture of seagulls, which he accidentally captured in the foreground (page 14). We were so excited that he had caught the seagulls in flight that "the picture of the shrimp boat" became something quite different. JOHN began proudly showing it as "a picture of seagulls with a shrimp boat in the background." JOHN needed his teachers to see that it was a picture of a shrimp boat, and we needed him to see that it was a picture of seagulls.

Guiding JOHN to notice the seagulls in his picture was one thing, but the whole process of helping our students "see" made me very conscious of our power as teachers. **I couldn't help but wonder how all my teachers had shaped my way of seeing.** The image of a teacher reaching out to direct the focus of MERLETT's camera (pages 16–17) embodies the main question that troubled me: Does this image represent an empowering hand that helps us see or a controlling one that limits our way of seeing?

· · ·

When I began organizing the photographs collected from five years of the class, I tried arranging them in obvious groupings by student or in categories such as "sound," "touch," "home," and "friends." This felt incomplete. The collection was something more than a simple inventory of students' pictures. Only after looking for several years at thousands of pictures spread on tables in different configurations did another pattern begin to emerge: the images and stories fell into five groups that were about seeing, in the broadest sense. For the chapter titles, I use the physical behavior of light as a metaphor. **Light is what makes it possible for the eye to see—and for a camera to make photographs—but we don't usually see light itself.**

CHAPTER 1 represents DISTORTION of vision. We don't see the world exactly as it is; we merely perceive distorted representations of the world, like the shadows on the wall of Plato's cave. This chapter includes MERLETT's photograph of what she feared most: the lawn mowers and leaf blowers on campus (page 19). Their sound bounced off the buildings, seeming to come from every direction, and caused MERLETT to envision the machines chasing her.

CHAPTER 2 concerns a REFRACTION of the world. When light travels through a prism, it refracts into its many parts—from violet to deep red—so they can be seen. If we focus on only one part, such as red, we could be misled into believing that the whole world is red. MERLETT took a close-up picture of a chain (page 37), which at first glance looks like a noose. On the one hand, since the picture focuses exclusively on one part of the chain, it is difficult to see that the chain is connected to a bell heard across campus. On the other, focusing closely on one part sometimes helps us see better. In TAMEKA's close-up picture of a tree (pages 56-57), we are able to see what the tree feels like.

CHAPTER 3 is an exercise in REFLECTION—self-exploration and expression, some of which resulted from self-portrait assignments. Several students photographed their doll collections. "This is kind of silly," MELODY explained, "but when I was eight, my mom was gonna have a baby. And I was pretending the other little doll was acting the way I acted when I was jealous."

CHAPTER 4 reveals a growing TRANSPARENCE between the students and the world, as they navigate issues of race, trust, friendship, intimacy, and empathy. MERLETT, a black student who once told me she disliked white people, didn't realize that her best friend, REBA, was white. "She doesn't act white?" I asked. "How does she act?" MERLETT simply said, "Like us."

CHAPTER 5 is about ILLUMINANCE. Some of the world can't be seen because we can't illuminate it. KATY wanted to photograph the wind, but we weren't sure how she would do this. When her pictures returned, we saw leaves scattered across the ground (page 123).

I thought of these five groupings as a journey toward light—toward an illuminance that is beyond everyone's eyesight—although the source of light is not fully known. The road is already dark enough as we wade through distortions and refractions to explore ourselves and our relationship with the world. Ultimately, we may catch only a glimmer of a picture larger than us—an image of the world that is just beyond our full grasp.

You can embark on this journey by reading the book backward, randomly, or by following themes that span the chapters, such as teenage life, the rural South, or ANTONIO's family photo album. Frequently photographed subjects are grouped together, such as boom boxes, ceiling lights, or personal objects on beds.

Not all the photographs have accompanying stories explaining why they were made. I patched together information from teaching notes, memories, taped interviews during the class, and text from the students' writing assignments. With some of the images, nothing remains except questions. Three questions I asked while compiling this collection were: **Which images do I find myself staring at, and why? How would I see these images if I didn't know the photographers were blind? If I consider their "point of view"—their experience with visual impairment—how might I understand the pictures differently?**

· · ·

My cousin Perry made his Christmas gifts by hand; jigsaw puzzles of family pictures were my favorite. The true gift was working with my parents, brother, and sisters to see how the pieces fit together. When we first opened his puzzles, we each took one piece and tried to guess the whole picture. No one ever got it right. The most challenging part was to place a piece in a section where everything looked the same—a cloudless sky, a perfectly tended lawn, a blank wall. In these sections, all we had were the cracks between pieces to reveal how they fit together.

Perry's puzzle reaches out across the world for me now—a picture of everything we are constantly putting together. The five chapters in this book represent an ongoing pilgrimage to see this larger picture. I attempt to imagine the whole, as I search for where my piece fits.

The fact that I had not noticed the cracks in the sidewalks at Governor Morehead School has stayed with me for years. LEUWYNDA's story is about more than cracks in a sidewalk; it is about all the cracks that go unnoticed. I began wondering what other cracks I unconsciously step over. Sometimes they may be small—saying names wrong, not showing gratitude, being overly judgmental. Sometimes the cracks are much bigger—the prejudice I still have about other cultures; the privilege I have by virtue of my skin color, gender, and education; and **the illusion that I know anything with certainty.**

At the beginning of the photography class, the students' pictures seemed banal—trees, pets, clocks—or simply like mistakes. If I had found all the pictures from the project in an unmarked box in my grandmother's attic, I may have disregarded them. KATY's pictures of the wind would only be images of dead leaves. As soon as I understood the hidden meaning behind LEUWYNDA's sidewalk pictures, everything looked different. All the images became unfamiliar, as if they were puzzle pieces that held a secret about how to see a much larger picture.

Each new piece I notice, whispers—in a still, small voice— *pay attention to the cracks.*

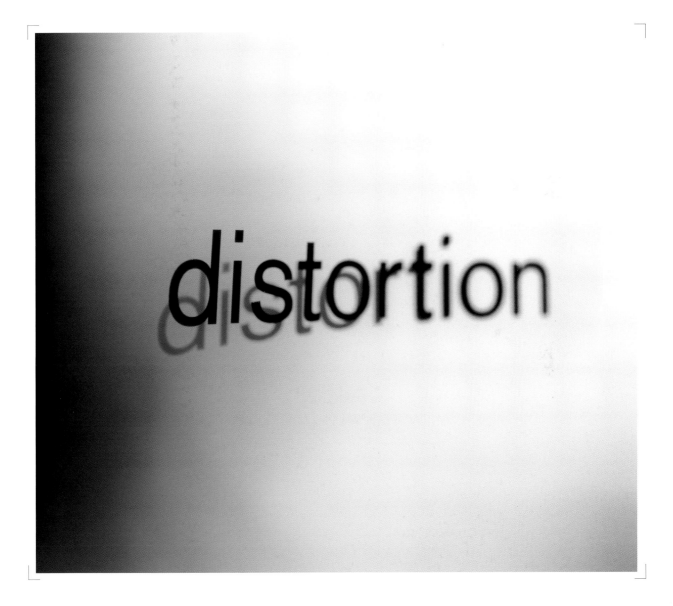

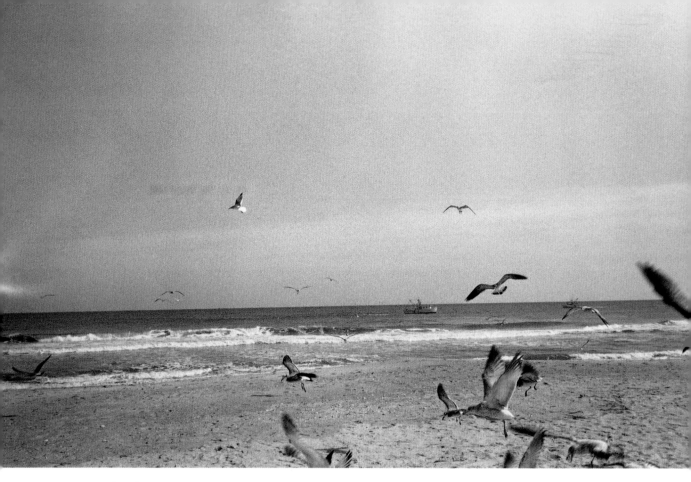

JOHN V. | age 19 : Carolina Beach, NC | A teacher reviews John V.'s first roll of film.

Oh, I love this picture of these birds. Because, you see, it's like you've got all these birds just flying around. What are those called?

Seagulls.

And you've got the horizon in the background. And you've got the water coming in. It's sort of a nice ground-level shot. Do you remember?

What do you see in the background?

The background? There's the surf.

I believe there was a shrimp boat out there.

His name is "Bully." He's part pit bull and chow, I think.

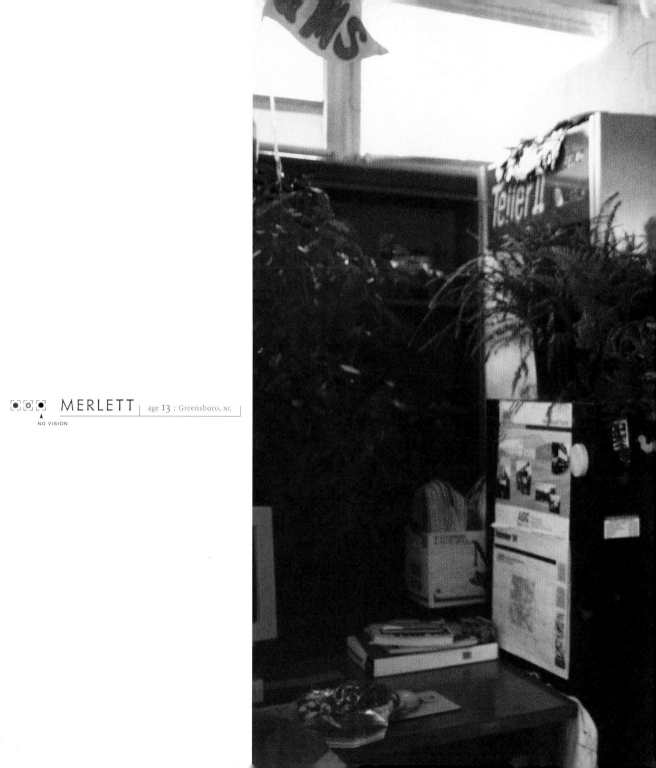

MERLETT

age 13 : Greensboro, NC

▲
NO VISION

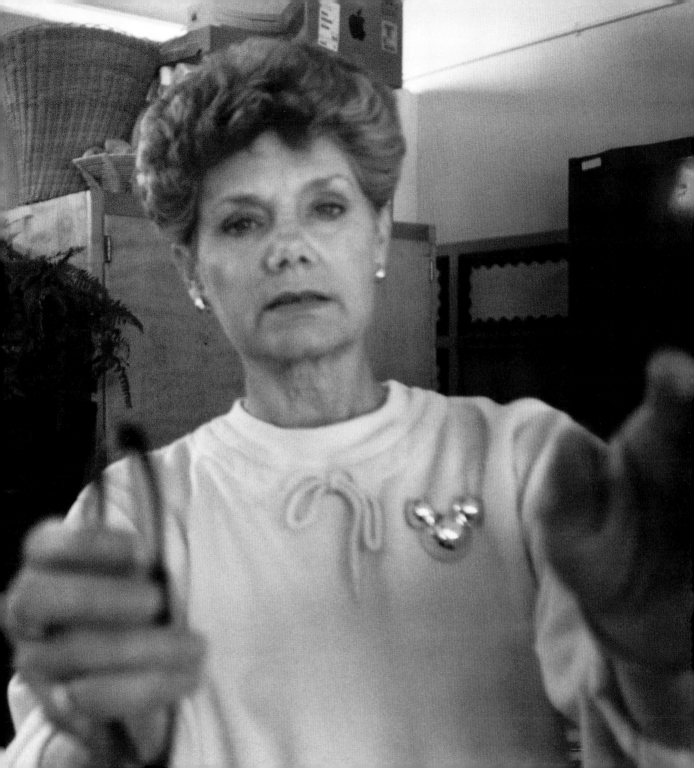

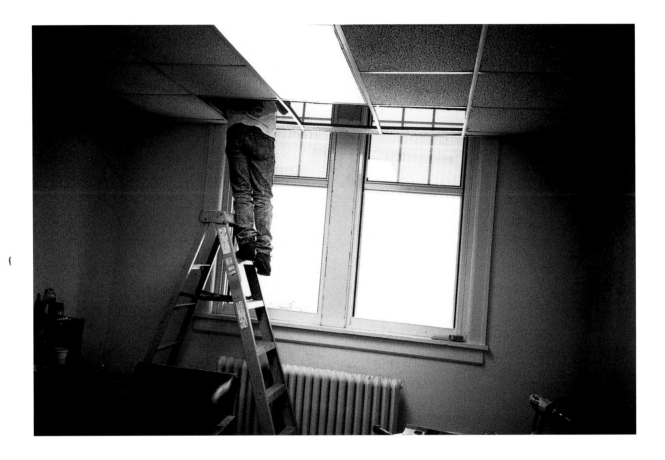

MERLETT | age 13 : Greensboro, NC

Motorized equipment can be scary—especially if you can't determine where it is located. The sound of lawn mowers and leaf blowers in the middle of campus would bounce off the buildings and come from every direction. Merlett would imagine the machines chasing her around. One day, Merlett decided to turn the tables and chase the machines—to take a picture.

◉ ◎ ◉ MERLETT | age 13 : Greensboro, NC |

▲
NO VISION

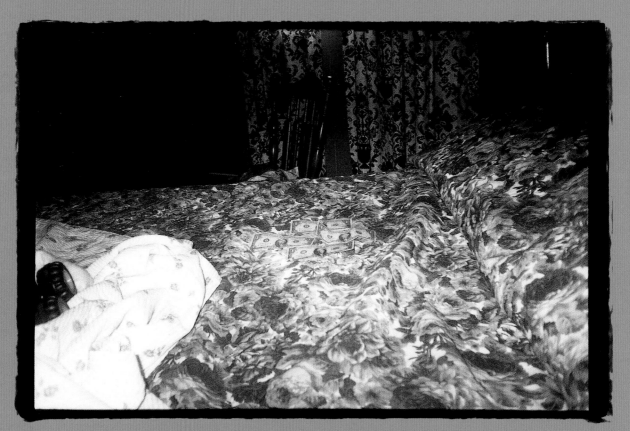

I wanted a picture of all my money.
I thought it was more than four dollars.

███ ▣ ▢ ▣ ■ ANTONIO │ age 13 : Enfield, NC │
▲
LOW VISION

Antonio's family photo album

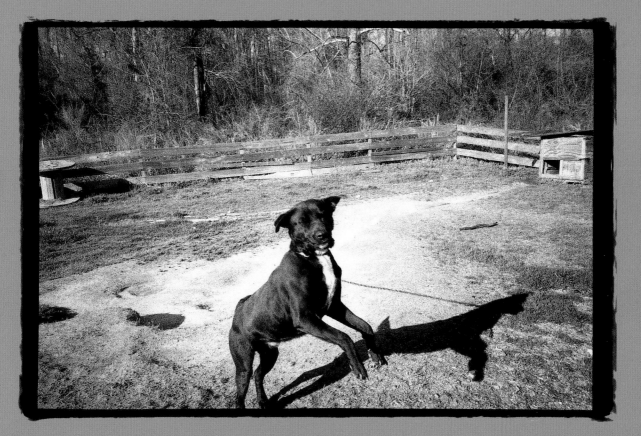

Last night I dreamed that a bulldog got after me.

MELODY | age 15 : Raleigh, NC |

We went to Boston two weeks ago. This is the steep staircase we had to go up to get to our rooms. I took a picture of it because I will always remember almost falling down the steps the first night. I'm not used to staircases that do that—that go around in like a circle. I was like, "wooo."

 FRANCES | age 12 : Chadbourn, NC |

LOW VISION

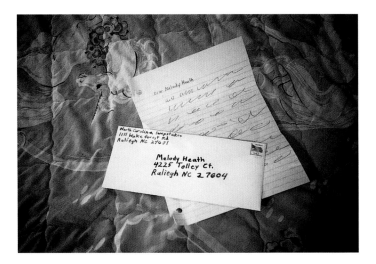

MELODY | age 15 : Raleigh, NC |

Melody wrote herself a letter to illustrate her dream of winning the lottery.

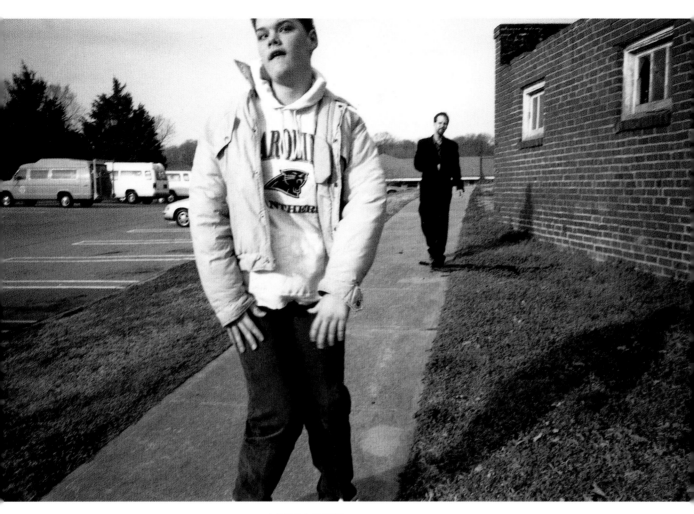

◉ ◉ ◼ MERLETT | age 13 : Greensboro, NC |

▲
NO VISION

Students collaborated to photograph a dream.

Chris just kept running.

I work at a business not too far from my house.
I have five or six white guys and two black guys
I works with. I load trucks. And I roll tires and
stuff like that. That's basically what I do. See,
I mostly just hang around and talk until they ask
me to do some work.

I know a bunch of people there. I've been know-
ing the boss man a long time—ever since I was
a young boy. I know how hard he has to work
'cause all these tires are stacked all around him,
and most of the time he has to climb over the
tires to get to where he has to air them up at.
It's pretty hard.

I have a friend named Arthur. He's one of my
good friends. We pick on him a little bit. Some-
times we call him "blackie." Sometimes we call
him "the small-headed black guy." We just pick
on him a lot. It's funny too. Or sometimes we
call him "black boy."

My friend Alan, we pick on his nose a lot. His
nose is big. Most of the time when you hear
a fire truck go by, that's him blowing his nose.

My friend Bobby, he's real big. We call him
"two-car garage." Man, I tell you, he makes
me laugh.

ALEX: I was thinking about how to describe her, and she looks like someone I know, but that is not going to help you.

JOHN: What's she look like?

ALEX: She's got on glasses. She's got what looks like dark-colored hair. It comes down to her shoulders.

JOHN: Does this girl you talk about look good?

ALEX: Oh man, how to answer that question? Does she look good? What's "good"?

JULIA: Yeah. She looks very . . .

JOHN: (laughs)

JULIA: . . . she's got a very cute smile.

JOHN: (laughs) That's my girlfriend.

JOHN: She didn't want me to take that picture.

ALEX: She's smiling as if she wanted you to take the picture.

JULIA: She's lookin' a little shy. Why didn't she want you to take her picture?

JOHN: She doesn't think she looks good in a picture.

JULIA: Actually, I think she was very interested in having her picture taken.

JOHN: (laughs)

ALEX: This doesn't look like a picture of a woman who didn't want her picture taken. This is a picture of a woman getting ready to have her picture taken.

Visitors to the school—Alex and Julia—describe what they see in John V.'s most recent photographs. John is curious about how one girl in particular looks in many of his pictures.

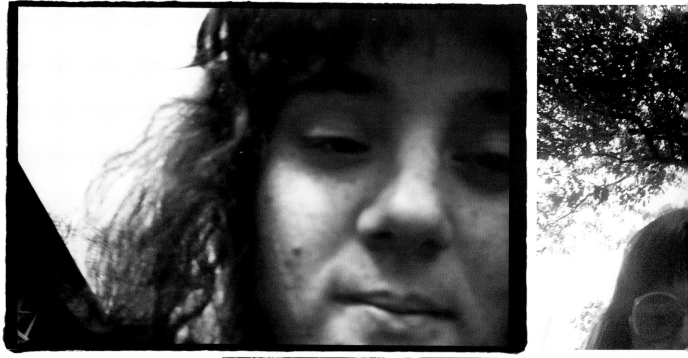

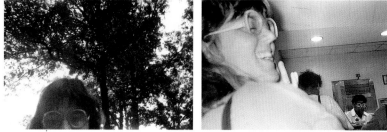

●●●●● LEUWYNDA | age 18 : Jacksonville, NC |
▲
LOW VISION

●●●● JACKIE | age 15 : Greenville, NC |
▲
LIGHT PERCEPTION

The school yearbook surveyed students, asking,
"What do you look for in a boyfriend?"

answer #1: "The guy has to be cute."
answer #2: "He has to know how to dress."
answer #3: "He's got to remember all special holidays."

LEUWYNDA | age 18 : Jacksonville, NC

A teacher describes Dean's pictures from a field trip to a poll site during the 1993 presidential election.

You know what I like about this picture? It's like you've got all these people lined up waiting to vote, and they all look so different from each other. They're old people and young people and black people and white people, and some people are dressed up, and some people just have on shorts and gym shoes—all kinds of different people all together. It's like they're standing in the sun and there's a shadow.

What kind of shadow is it?

Well, it's the shadow of them. Each one of them has their own shadow that extends all the way out to the edge of the picture. It's like the shadow is so much longer and taller than they are. And it's like the shadows make them all look the same, you know?

(smiles) I took a picture of their shadows.

refraction

▲
NO VISION

The chain connects to a bell heard across campus.
It signals the beginning of classes, breakfast, and
lunch, and it rings at graduation. General Sherman's
Union soldiers gave the bell to the school during
the Civil War.

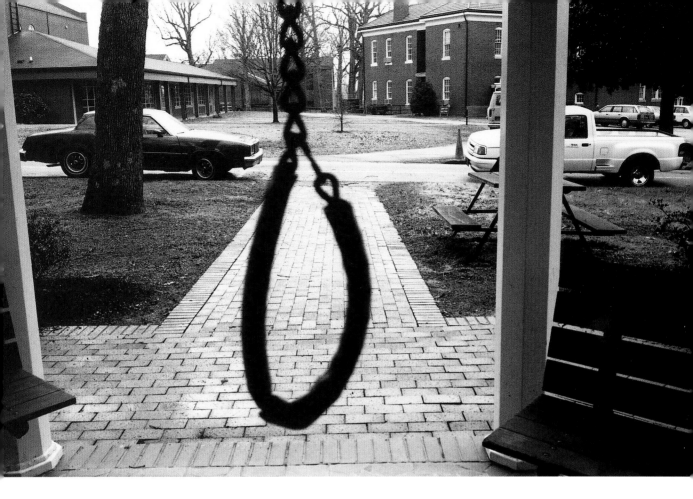

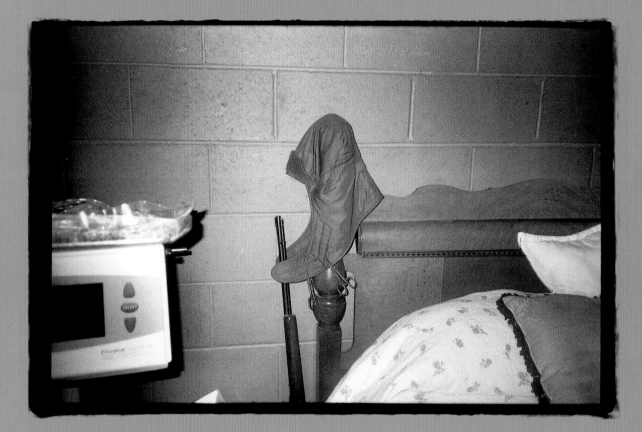

This is my Uncle Butch's gun. It looks like someone's holding the gun because the hat is wrapped around it.

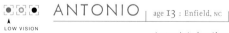

LOW VISION

ANTONIO | age 13 : Enfield, NC |

Antonio's family photo album

This is my Uncle Butch.

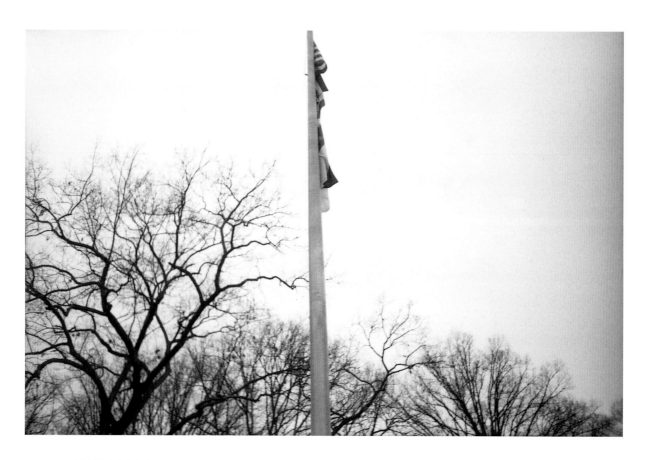

WILLIAM | age 18 : Kannapolis, NC

This one I took of the American flag, which was being lazy.

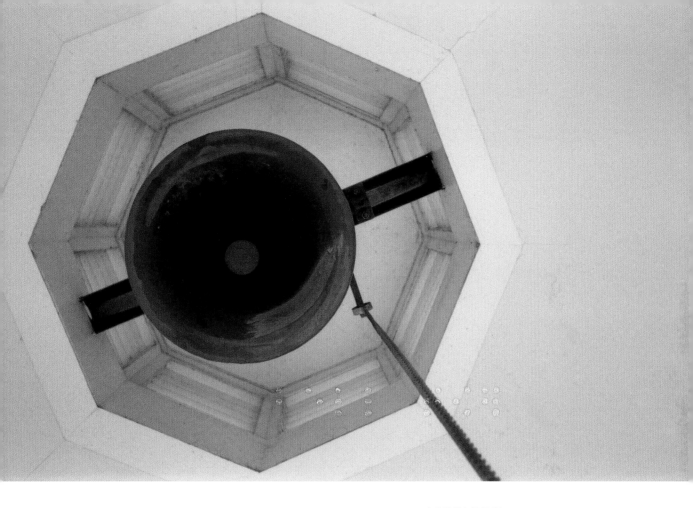

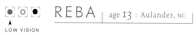
REBA | age 13 : Aulander, NC |

▲
LOW VISION

BRYAN | age 12 : Stanley, NC |

▲
NO VISION

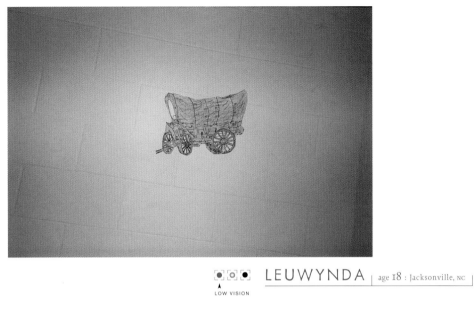

LEUWYNDA | age 18 : Jacksonville, NC

LOW VISION

PAM | age 16 : Smithfield, NC

LOW VISION

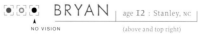 **BRYAN** | age 12 : Stanley, NC

NO VISION

(above and top right)

● ○ ● JONATHAN | age 15 : McCleansville, NC |
▲
NO VISION (bottom right)

TAMEKA | age 17 : Apex, NC

LOW VISION

pages 46–47

I was thinking
that it would be
sort of hard
for a blind person
to take pictures,
but it's not very hard.
You've just got to
listen.

—JOHN V.

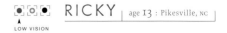

RICKY | age 13 : Pikesville, NC

LOW VISION

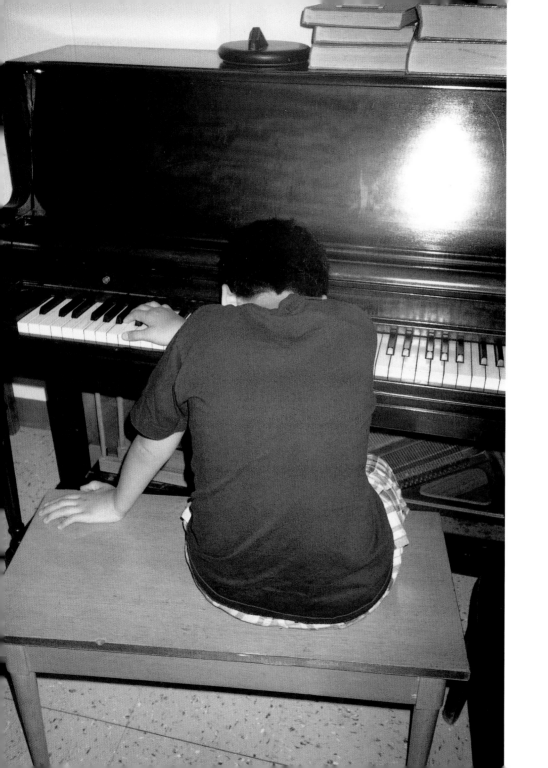

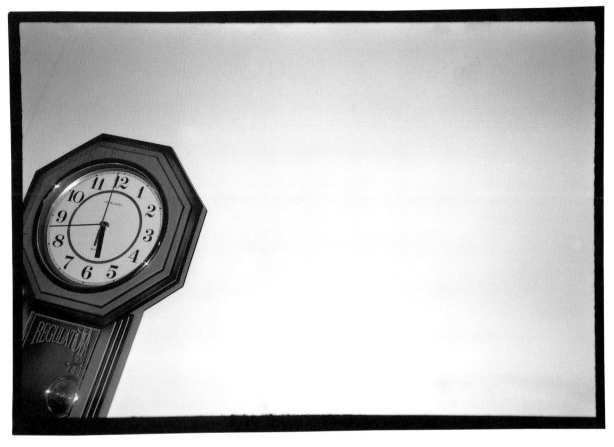

CASSIE | age 12 : Sanford, NC |

▲
NO VISION

Most clocks are cuckoo clocks. They
tick and cuckoo every hour and half hour.
I have other clocks also, but they are
not the same.

MERLETT | age 13 : Greensboro, NC |

NO VISION

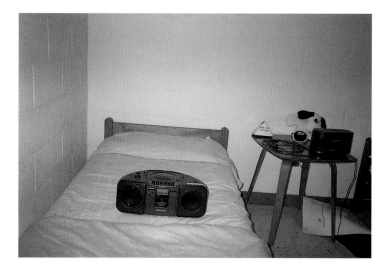

LEUWYNDA | age 18 : Jacksonville, NC |

LOW VISION

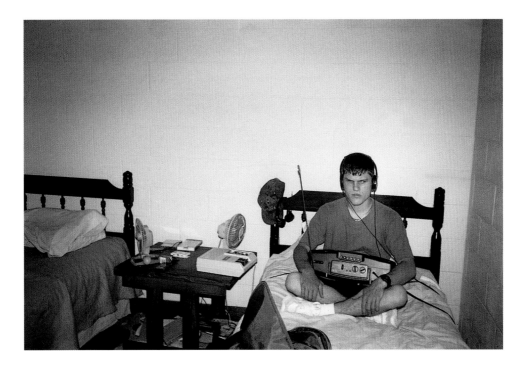

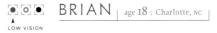 BRIAN | age 18 : Charlotte, NC

LOW VISION

It would be more fun if we got to take pictures of Metallica.

"And Justice for All" is a real, real long song. It's a song about how the government rules people and how the money that they make can ruin them and all that kind of stuff.

Metallica is the best group since groups began.

—BILLY

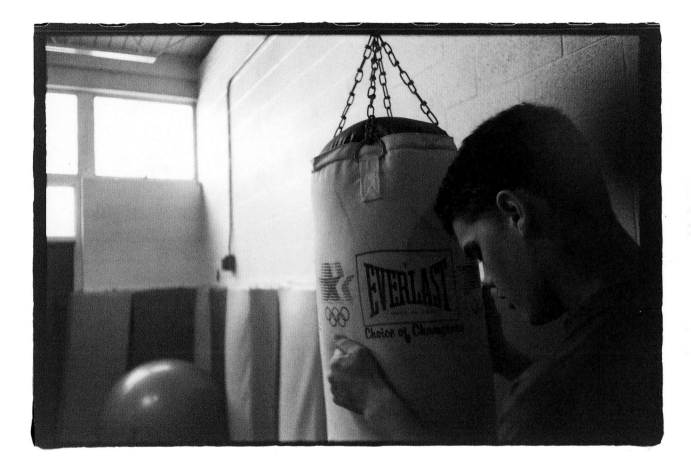

TAMEKA | age 17 : Apex, NC
pages 56–57

▲
LOW VISION

JUNIOR | age 17 : Raleigh, NC

▲
NO VISION

 WENDY | age 17 : Raleigh, NC |

▲
LOW VISION

A teacher asks Jonathan about taking pictures.

Had you taken pictures before?

By myself? No.

Did you think you could do it?

Yeah, but focusin' on something wasn't too easy, though, 'cause I couldn't see nothing.

How did you do it?

Just feelin' what I'm aimin' for and then go back and aim at it—right at it and push the button.

What kind of things did you take pictures of?

A toilet.

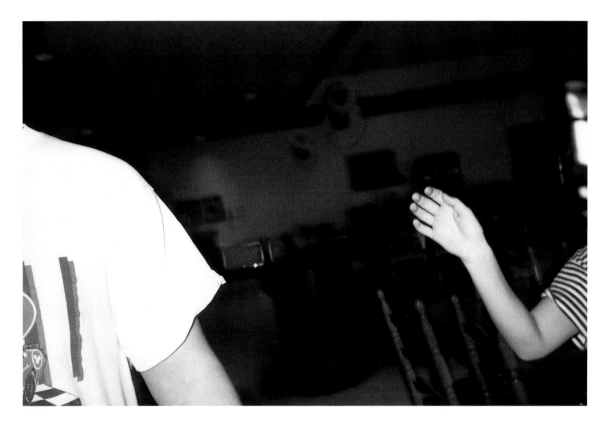

 MERLETT | age 13 : Greensboro, NC |

NO VISION

◉ ▣ ● MERLETT | age 13 : Greensboro, NC |

▲
NO VISION

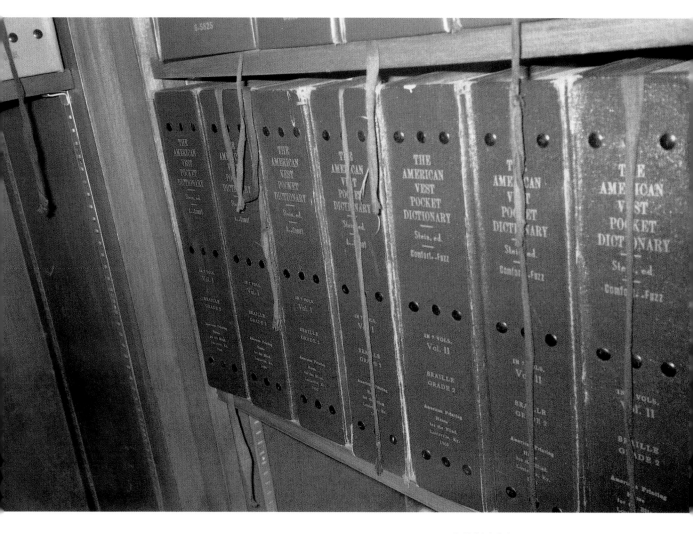

BRYAN | age 12 : Stanley, NC

NO VISION

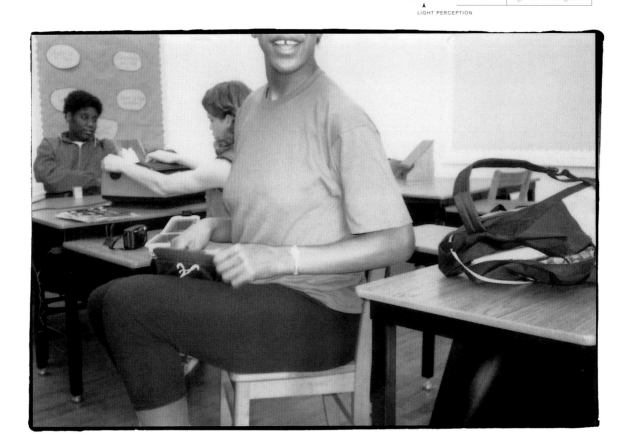

My friend Pam, she's real tall, right?
I took a picture, and the head was chopped off.
You have to keep the camera level and make
sure you get the person in all the way.

That's how you can take a "good picture."

—JACKIE

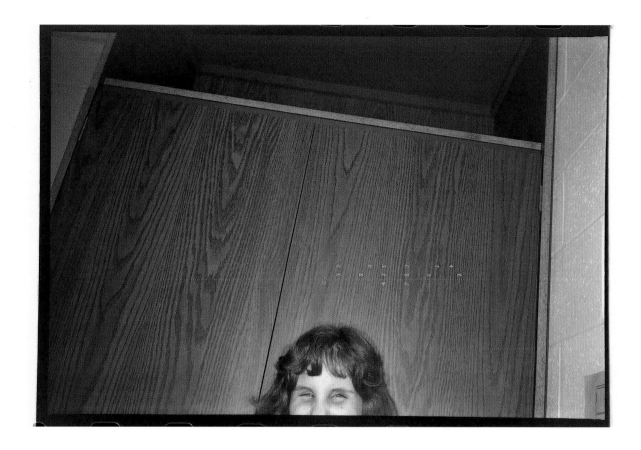

I learned that using a camera and taking pictures is kind of an art. I did a few crooked pictures just to see what they look like. That was pretty interesting.

——MELODY

That was another one of those using-film-to-see-what-would-happen shots.

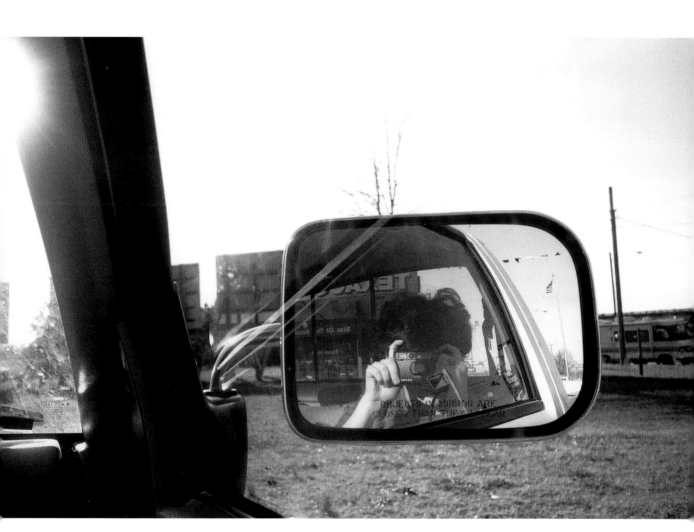

REBA | age 13 : Aulander, NC |

self portrait

Objects in mirror are closer than they appear.

[1/24/95]

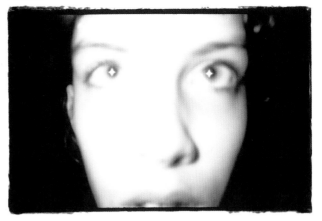

[1/19/95]

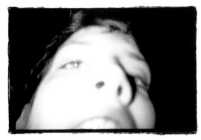

 FRANCES | age 12 : Chadbourn, NC |

LOW VISION

Frances capturing her eyes.

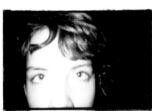

[2/15/95]

[2/17/95]

[3/6/95]

[3/23/95]

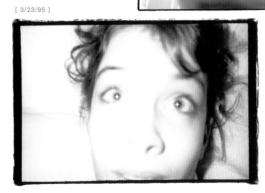

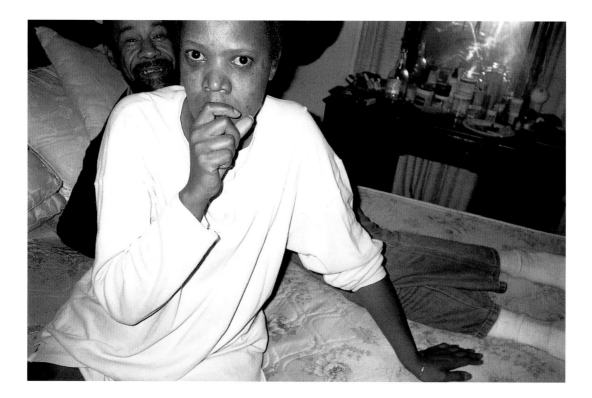

● ○ ■ MERLETT | age 13 : Greensboro, NC

▲
NO VISION picture of Merlett's mother

People say I look like my momma.

I say, "No, I don't."

This is kind of silly, but when I was eight, my mom was gonna have a baby. I pretended the little doll was acting the way I acted when I was jealous. I didn't like it that she was bringing someone else in the family. It's not just gonna be me anymore.

The baby came, and I really liked it. And the doll said, "It's not bad havin' a baby around." And that's how I felt.

I'm pretending that the baby is gonna have a vision problem—'cause she can't see the bottle—she can't see things really close. The baby doesn't understand—she just says she can't see. They think it is someone's fault. Their grandma said that her great-uncle had a vision problem, and they think it was his fault.

We pretend that she likes riding her little tricycle and that she wants to be a bus driver or somethin'. But her family is like, "We don't know if you could do it." I think she could. I mean, I'm dreaming that I can get my license this summer.

—MELODY

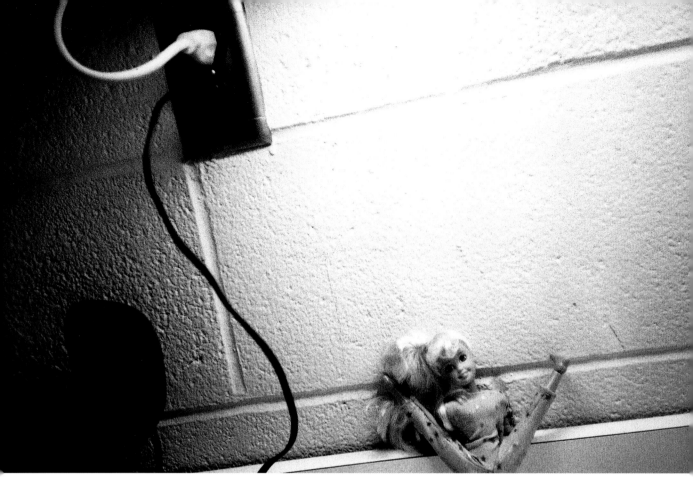

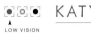 **KATY** | age 13 : Kennesaw, NC

LOW VISION

This was supposed to be my bed. It became a picture of my dresser.

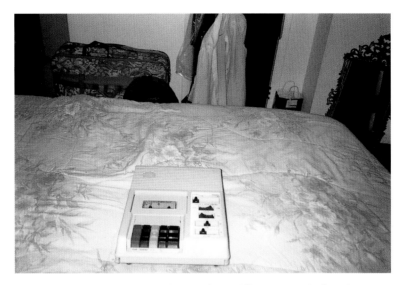

I can learn about different people from listening.

Sometimes music describes how I feel.

LeuWynda

1 extinct
2 extinct
3 extinct
4 extinct
5 extinct
6 extinct
7 extinct
8 exitnct
9 ~~extinct~~
10 exitct

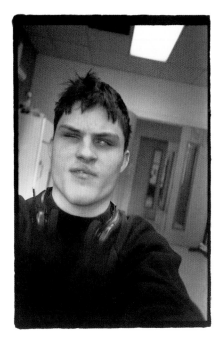

◦◦◦◦ DAIN | age 18 : Castalia, NC

▲
NO VISION self-portrait

Must've did right good, kind of hard to miss yourself.

■ □ ● JOHN V. | age 19 : Carolina Beach, NC |

▲
LIGHT PERCEPTION self-portrait

I sort of took pictures of myself to give to
other people and also so my teacher would
know whose film it was.

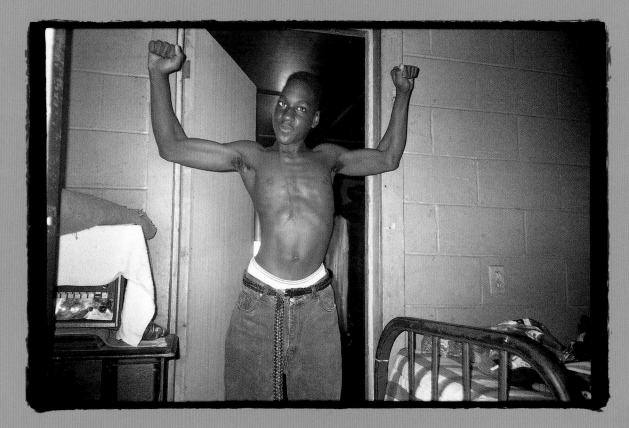

I am Antonio. I am showing my muscles.

LOW VISION

ANTONIO | age 13 : Enfield, NC

Antonio's family photo album

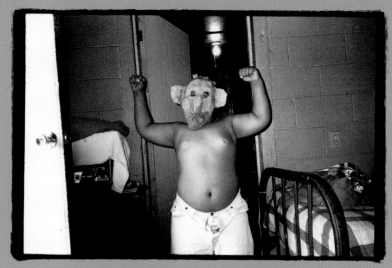

This is my cousin Lerrod trying to be like me.

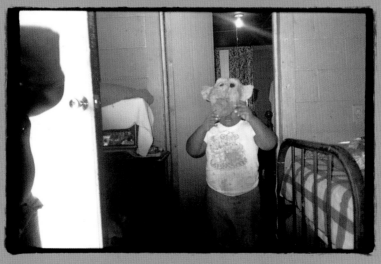

Chris always tries to follow the big boys. When
I was little, all my cousins liked to hang around me.

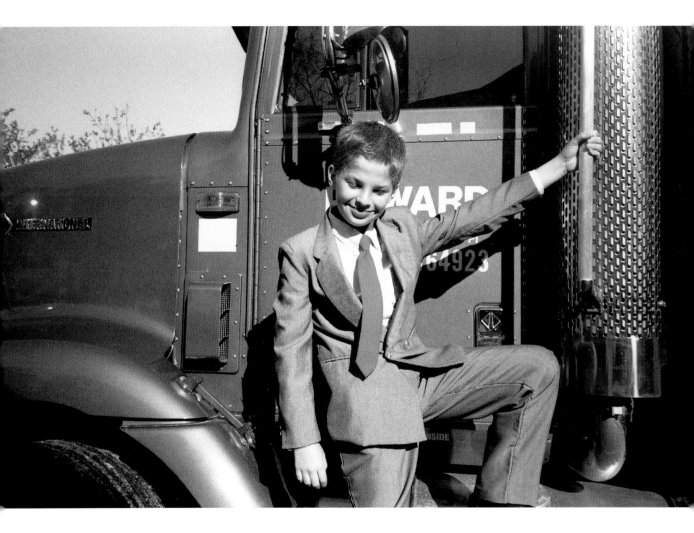

RICKY | age 13 : Pikesville, NC |

LOW VISION

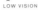
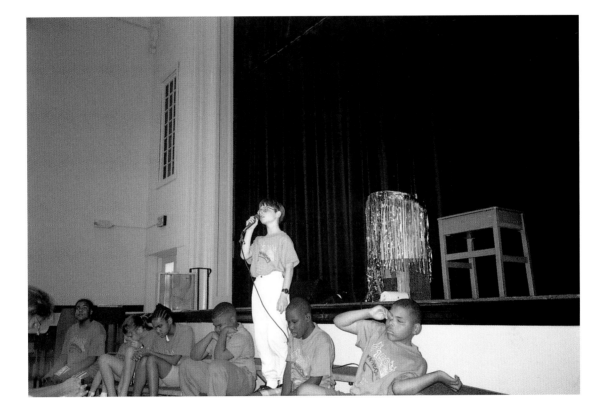

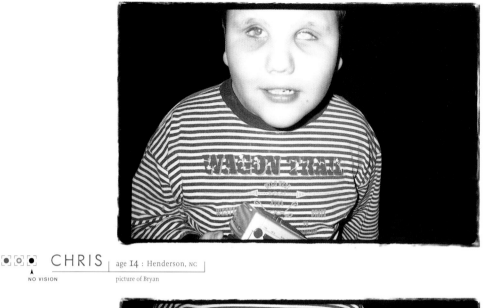

□ □ ■ CHRIS | age 14 : Henderson, NC
▲
NO VISION picture of Bryan

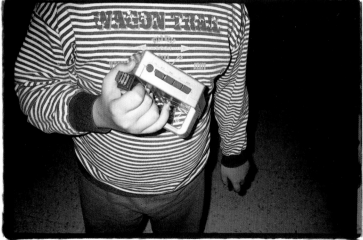

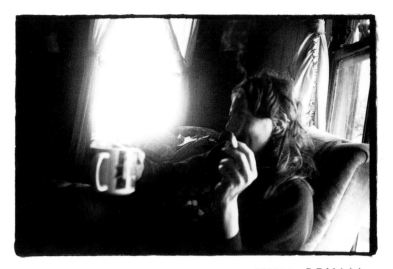

○ ○ ● BRYAN | age 12 : Stanley, NC |

▲
NO VISION

picture of Bryan's mother and sister

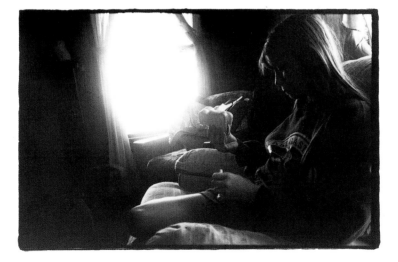

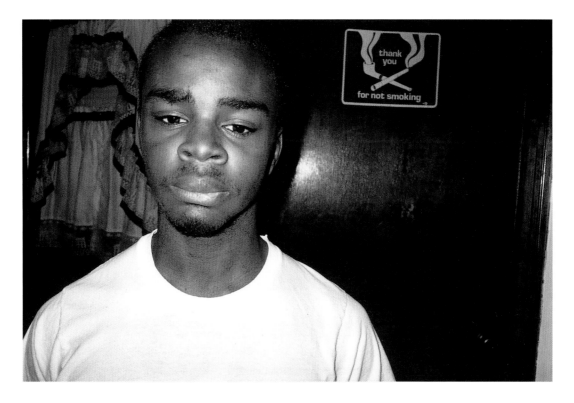

MERLETT | age 13 : Greensboro, NC

NO VISION

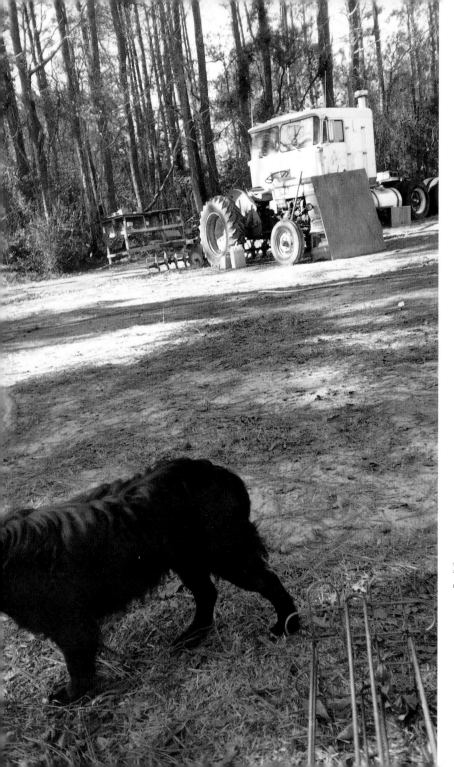

NIVEA | age 13 : Bolivia, NC

My
dog,
Shadow,
is
looking
for the
puppies.
There
are
no more
rabbits
in the
cage.

My
father
has
killed
them
or let
them
die.

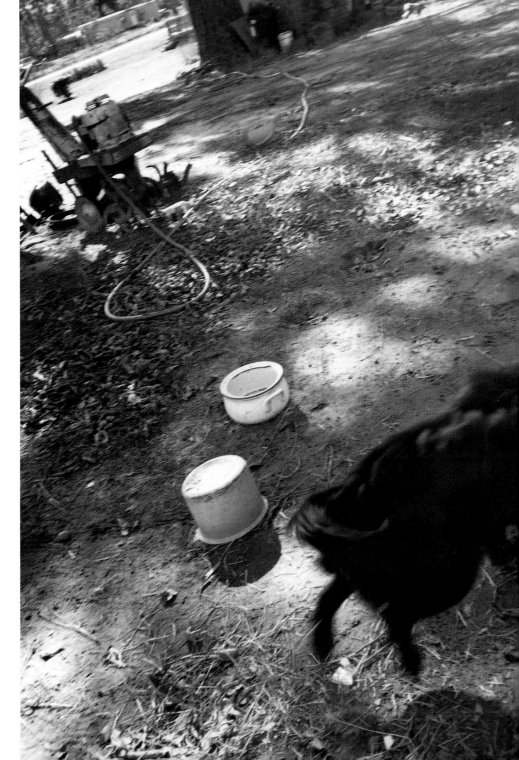

I just set the camera up on a shelf and pushed a button to make it go by itself. I stood back and held my teddy bear.

That's the teddy bear my ex-boyfriend gave me on my birthday. We broke up the day before Valentine's Day. It just tore me apart, because I was just sittin' there in the corner like, "I don't have no one." I mean, I cried the whole night.

He asked me last night if I can come back to him. And I said, "I don't know. You hurt my feelings so bad." Anyways, I'm kind of going with another boy, but we haven't really made it serious. He's younger than I am. I don't know if I'm in love. I don't know if I just like him. I'm just so confused.

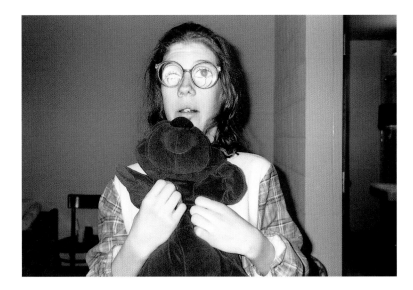

 MELODY | age 15 : Raleigh, NC

LOW VISION

self-portrait

This is a picture of my *real* face.

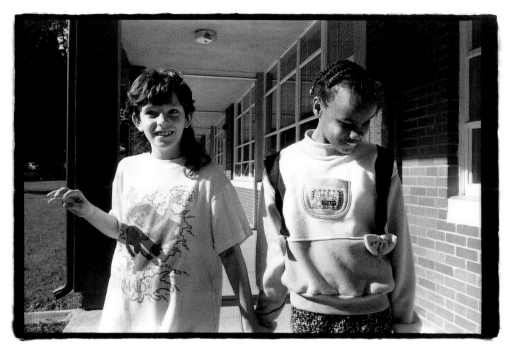

Teachers asked Merlett (right) about the photograph that Billy had taken of her and her best friend, Reba.

Tell me about Reba. Reba is white, isn't she?

Don't ask me. I don't know.

You don't know if she's white?

Is she? Well, she has long hair—
that's all I know.

Yeah, she's white. She doesn't act white?

(shakes head)

How does she act?

Like us.

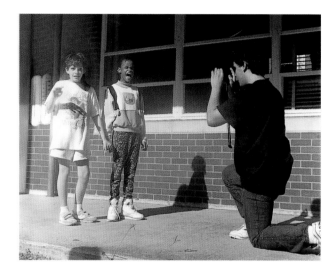

Billy taking a picture of Reba and Merlett.

They were standing there, and I just snapped and said, "I have your picture."

Reba is the real friendly one, and Merlett is sort of shy. Whenever I used to work with them, they were always playing around and stuff. And I helped them into new things. Like there's these little rails that Reba likes to flip over, and Merlett was scared to do it, and so we—me and Reba—helped Merlett overcome her fear and flip over the rail.

—BILLY

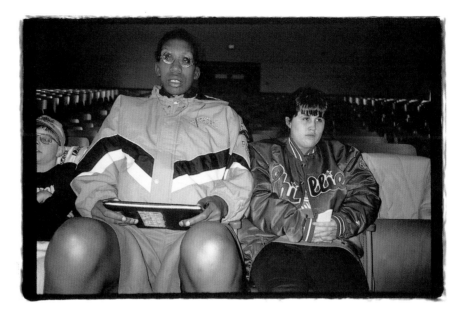

◨◧◨◨ FRANCES | age 12 : Chadbourn, NC
▲
LOW VISION

Pam (left) and Lisa

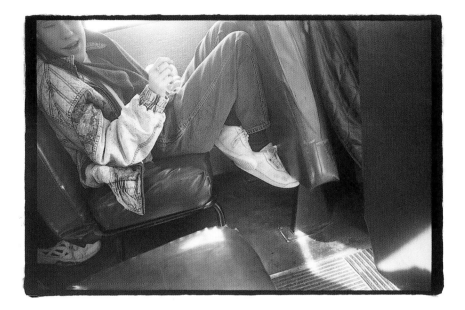

⬛◻⬛ TAMEKA | age 17 : Apex, NC |
▲
LOW VISION

I got stuffed in a locker at
least five times last year.

Kids just bein' mean.

—MELODY, before attending Governor
Morehead School for the Blind

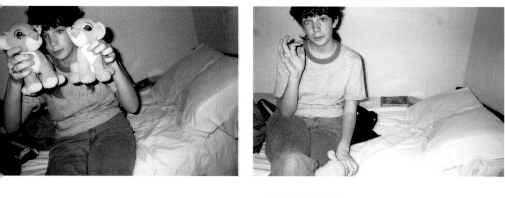

MERLETT age 13 : Greensboro, NC

NO VISION

picture of Reba

DAIN | age 18 : Castalia, NC |

NO VISION

■□■ JON P. | age 16 : Hope Mills, NC

▲
LOW VISION

You know how in seventh grade everybody leaves you alone? You're sitting at the cafeteria table pretending to read a book when you know you can't see the print.

—CAREY

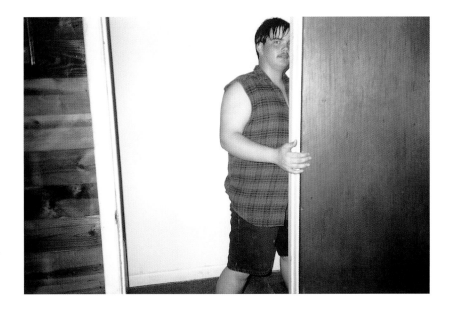

 FRANCES | age 12 : Chadbourn, NC

LOW VISION

One time we went to "Food 'n Folks," and I was running down the aisle trying to catch my sister, Taylor. Even though I didn't know where she was, I could hear her. My brother (pictured) said, "Walk straight. There she is." And I went straight into this woman. (laughs)

He's easy to trust 'cause he's my brother. If I can trust him with ten dollars, I know I can trust him with anything.

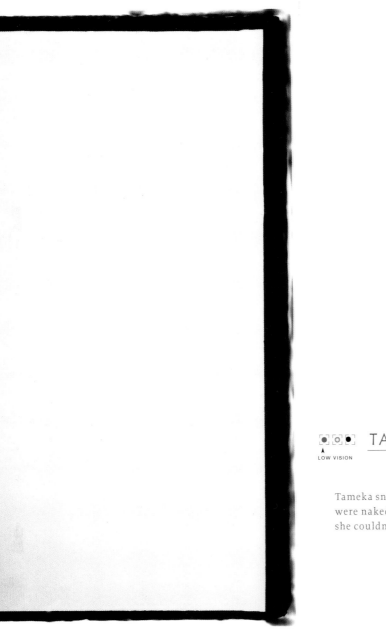

● ○ ● ●
▲
LOW VISION

TAMEKA | age 17 : Apex, NC |

Tameka snuck pictures of people who
were naked and claimed that it was because
she couldn't see.

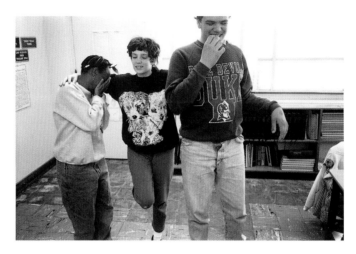

 LEUWYNDA | age 18 : Jacksonville, NC |

LOW VISION

Merlett, Reba, unknown (left to right)

Assignment: photograph what you hate.
Leuwynda hates feeling out of balance.

◉ ◎ ◉
▲
LOW VISION

FRANCES | age 12 : Chadbourn, NC |

My stepdad was just being crazy.
He likes to make people laugh.
It was boring not havin' no daddy around.

I'm from Enfield. My name is Antonio. I have a mom named Judy and a sister named Shawnique. I have an Aunt Vickie. I have an aunt named Cilla. I have an aunt named Faye. I have an Aunt Renee and an Aunt Emily. I have a grandma named Emma. I have a granddaddy named Raymond. And I have an uncle named Butch. I have an uncle named Mike. I have a cousin named Dustin. I have a cousin named Lerrod. I have a cousin named Sherrasha. And I have a cousin named Mike. And a cousin named Desmond. And a cousin named Lucris. And a cousin named DJ. And cousins named James and Antonie. I got a cousin named Montel. All of my peeps are from Enfield.

We be hanging out on Friday night. We be loungin', listening to music, riding bikes, calling girls. We be wrestling sometimes. And sometimes we go to the store.

ANTONIO | age 13 : Enfield, NC |

LOW VISION

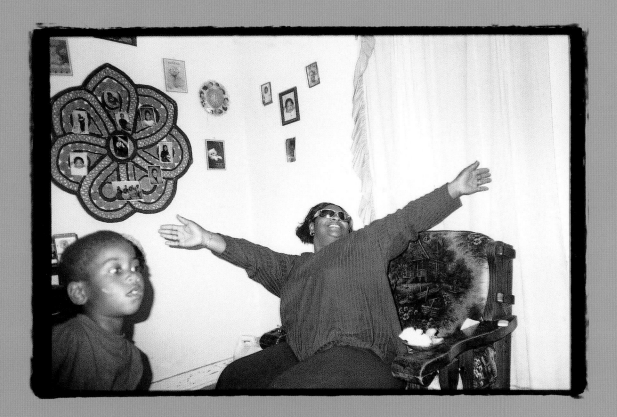

This is my Aunt Faye. It was Friday night.

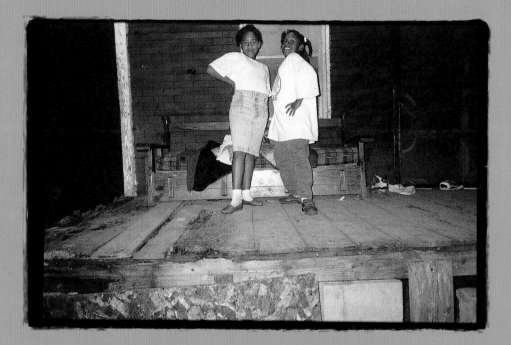

We were on the porch loungin'.

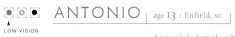

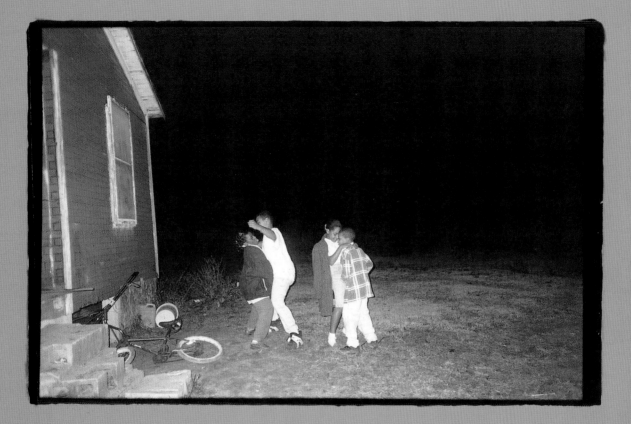

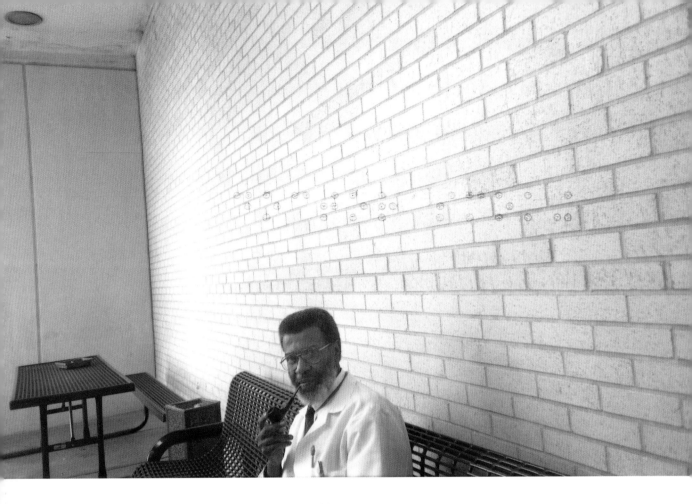

◉◯◉ JACKIE | age 15 : Greenville, NC |

▲
LIGHT PERCEPTION

I would like to interview a hurt person
or a doctor, maybe both.

They stuck Taylor (pictured) with a needle,
and she slapped the doctor. She's mean.
I started laughin' when Taylor slapped that
doctor.

I knew they was gonna stick her with a
needle. And I got mad because I knew she
was gonna start cryin'.

I've been stuck with needles so many times.
I'm used to it now.

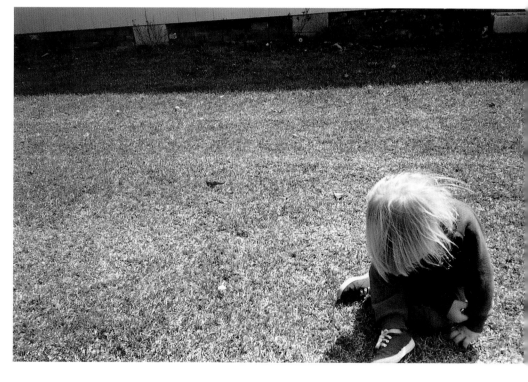

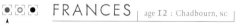 FRANCES | age 12 : Chadbourn, NC |

LOW VISION

How do you not cut people's heads off in a photo?

Just ask the person where they are.

—FRANCES

BRYAN | age 12 : Stanley, NC |

NO VISION

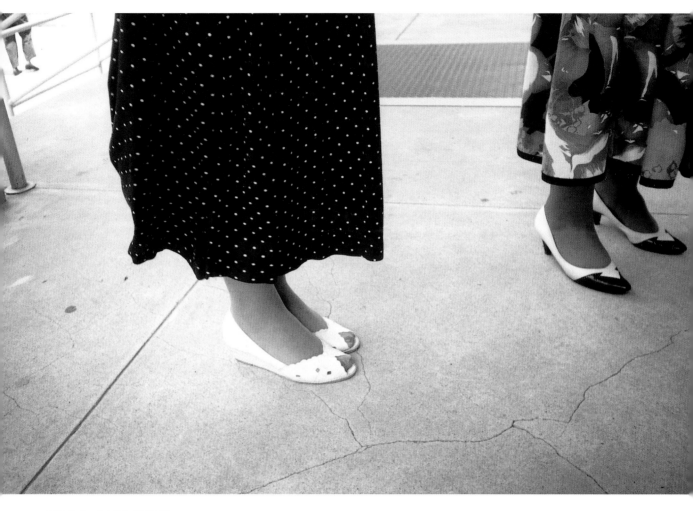

MELODY | age 15 : Raleigh, NC |

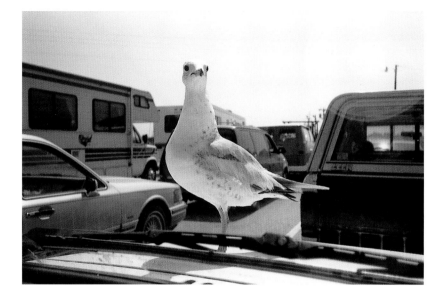

LOW VISION

CAREY | age 17 : St. Pauls, NC

Anytime a bird flies by,
she'll take my finger and say,
"Look, there's a bird!"

—MERLETT

◨ ◉ ◉ WENDY | age I7 : Raleigh, NC |
▲
LOW VISION

I would like to go to the Grand Canyon—just be in something that I can get in the middle of and take a picture.

And then maybe . . . maybe I would go out into space. Take a picture of a meteorite.

—JOHN V.

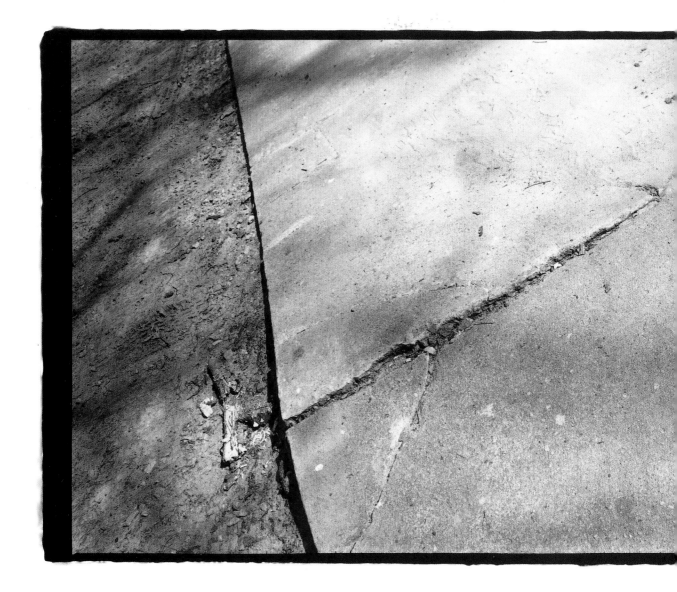

LOW VISION

LEUWYNDA | age 18 : Jacksonville, NC |

The journey across campus can be difficult because of the cracks in the sidewalk.
Leuwynda made photographs of the cracks as proof of the danger, which she
sent to the superintendent with a letter asking for them to be fixed. "Since
you are sighted," she wrote, "you may not notice these cracks. They are a big
problem since my white cane gets stuck."

KATY | age 13 : Kennesaw, NC |

▲
LOW VISION

Katy wanted to take a picture of the wind. The teacher wasn't sure how she would accomplish such a task. When her film was developed, the images revealed leaves scattered across the ground.

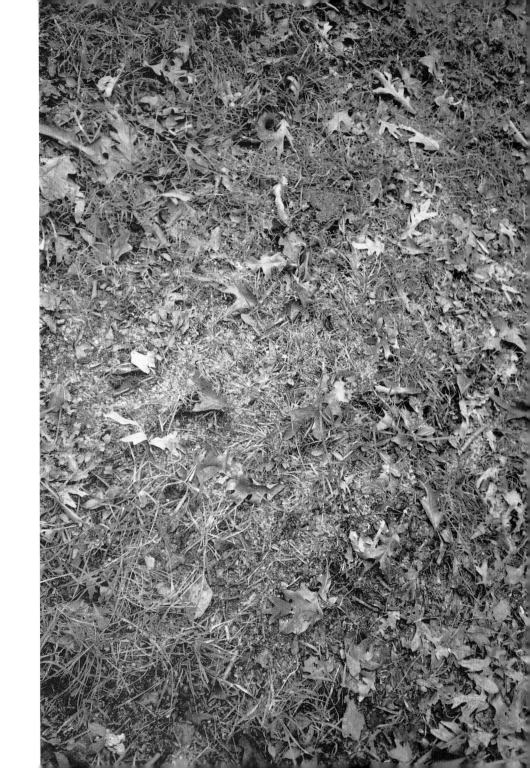

I killed that deer in the 229 block of the railroad on October 24 of '92. Dad had his 12-gauge, and I was sittin' down on the ground with my mom's 20-gauge double barrel—two-to-three-inch number-two buckshots in it.

The deer was behind us, and I kept hearin' him rattle, and I kept turnin' 'round, and finally my gun bumped Dad, and he said, "What?"

I said, "Are you gonna kill that deer that's behind you, or you gonna stand there all day?"

Dad said, "What deer?"

I said, "The one behind you!"

We were facin' the same way, only I was sittin' down. And he turned around and saw him. The deer had his head leanin' over toward the ground, and all you could see was the two prongs stickin' up. And about that time, he threwed his head up—he must have heard us or sensed us or somethin'—and Dad shot him, or shot at him. He shot a tree about as big as my arm and didn't even hit the deer.

Somethin' told me that deer was still alive. So, as we were walkin' over there to check him out, I had my gun layin' on my arm. When I heard him tryin' to move and get up, I stopped. I threw the gun up and knocked the safety off, and he was comin' by me with his nose at the end of the gun barrel.

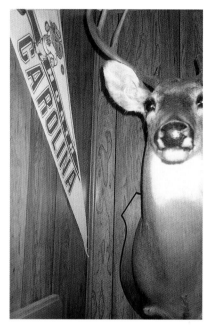

⊡ ⊡ ■ DAIN | age 18 : Castalia, NC

▲
NO VISION

Dad said, "Now!"

I shot him and shot one side of his rack off, but the taxidermist fixed it for me. My aunt and uncle mounted it and gave it to me for my sixteenth birthday.

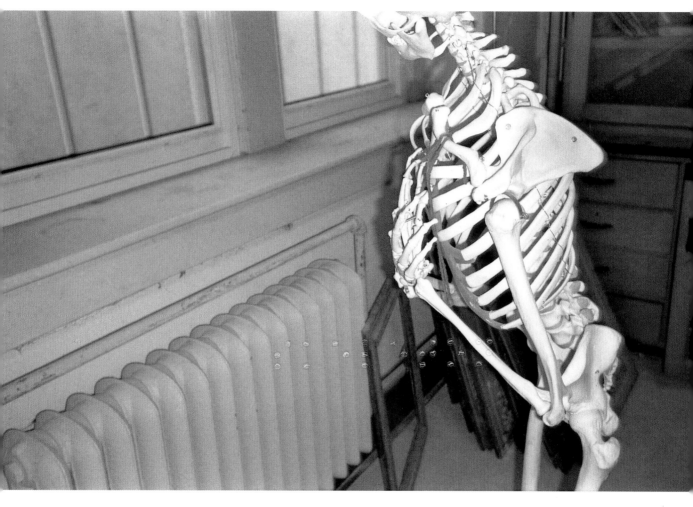

 CHRIS | age 14 : Henderson, NC

NO VISION

 MELODY | age 15 : Raleigh, NC |
▲
LOW VISION

Sometimes when I feel like I'm not safe, and I feel like something is going to hurt me, I go in my room and I read a book about unicorns. It makes me feel better.

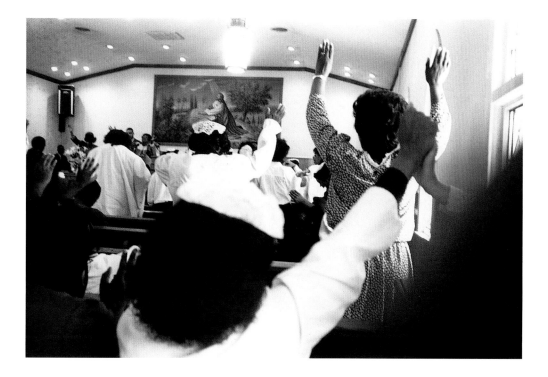

◉ ◉ ◉ PAM | age 16 : Smithfield, NC |
▲
LOW VISION

When I lost my eyesight, I would cry.
My mom would tell me that I was the
Lord's doing, and I would stop and pray.
Finally, I could see enough to get around.

—TAMEKA

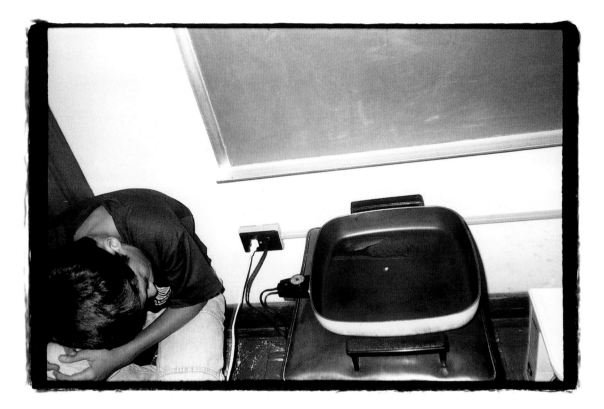

ANTONIO | age 13 : Enfield, NC |

LOW VISION

The popcorn experiment.

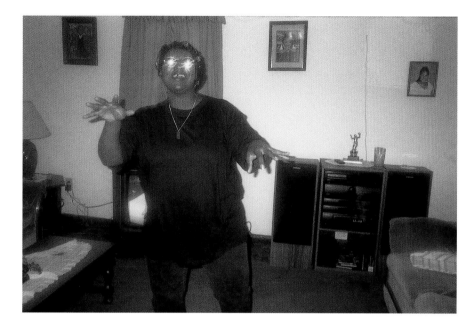

LOW VISION

TRACEY | age 19 : Wilson, NC |

WENDY | age 17 : Raleigh, NC |

LOW VISION

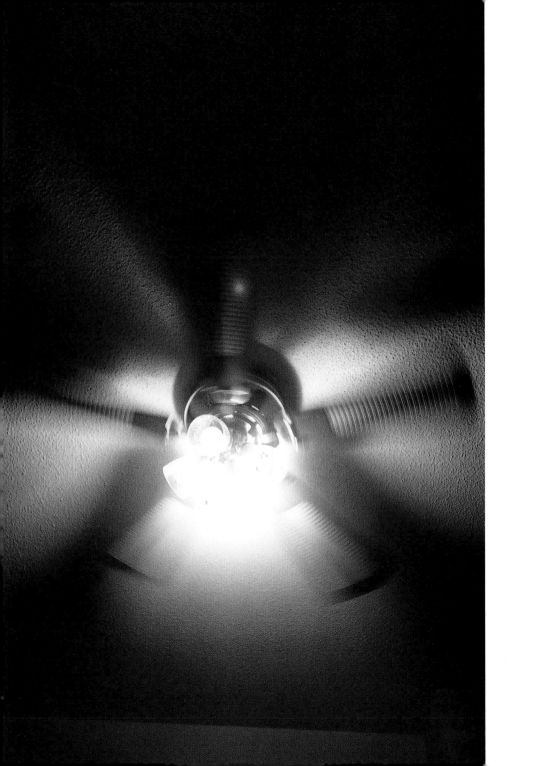

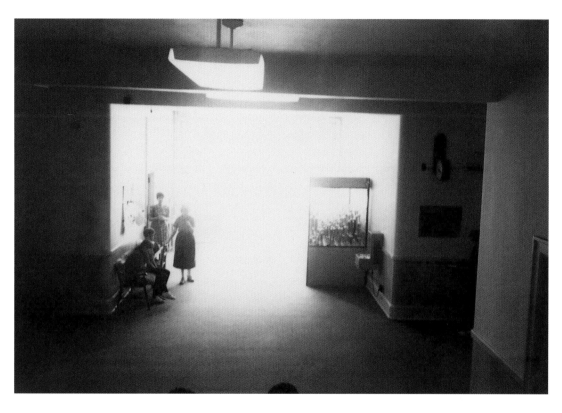

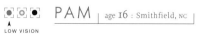 PAM | age 16 : Smithfield, NC

LOW VISION

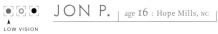 JON P. | age 16 : Hope Mills, NC
LOW VISION

 NIVEA | age 13 : Bolivia, NC
LOW VISION

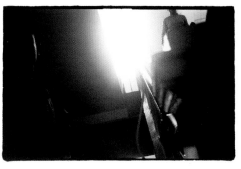

 TAMEKA | age 17 : Apex, NC
LOW VISION

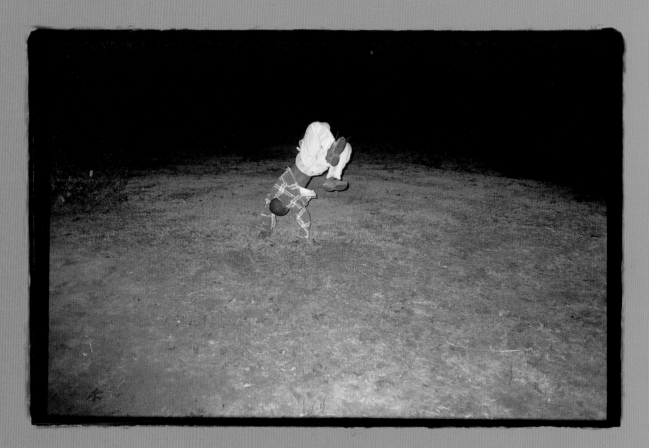

We were outside when I told Dustin to do a backflip.

ANTONIO | age 13 : Enfield, NC |

one day
there was
one storm
lined up
after a
nother.
I went on
the porch
and it was
dark. After
the storm
the sun was
shining
through the
raindrops.
A rainbow
came out
And I took
a picture
of it.

—JOSH

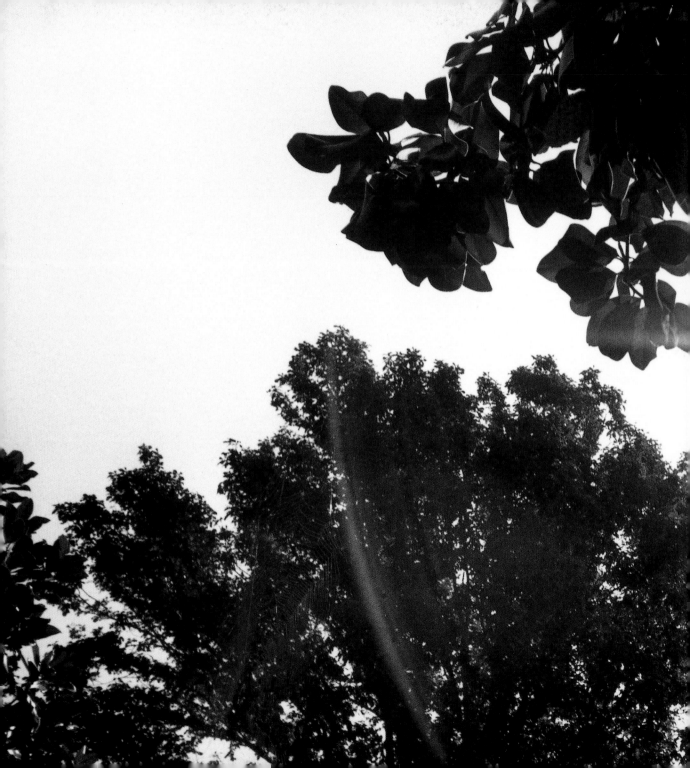

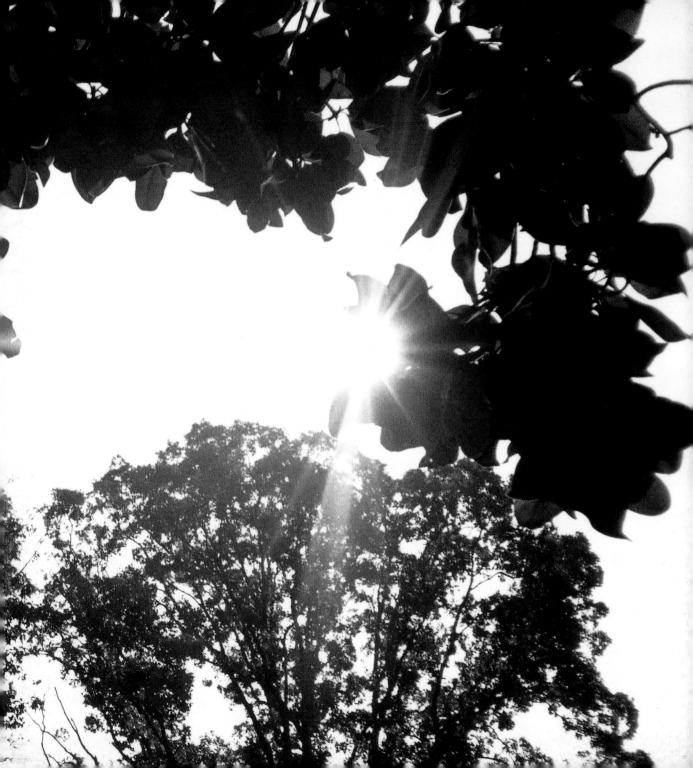

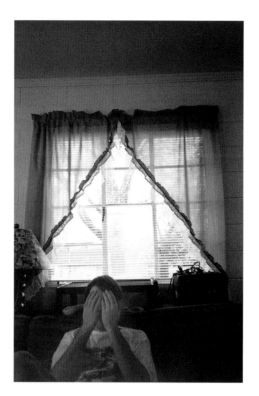

⊡⊡⊡ DAIN | age 18 : Castalia, NC

▲
NO VISION

If the lights are off, I can see what I'm doing.

—LEUWYNDA

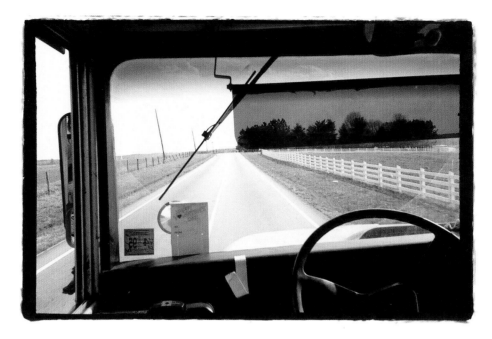

 WENDY | age 17 : Raleigh, NC |

LOW VISION

I know where I want to go, but I don't know how to get there.

—JOSH

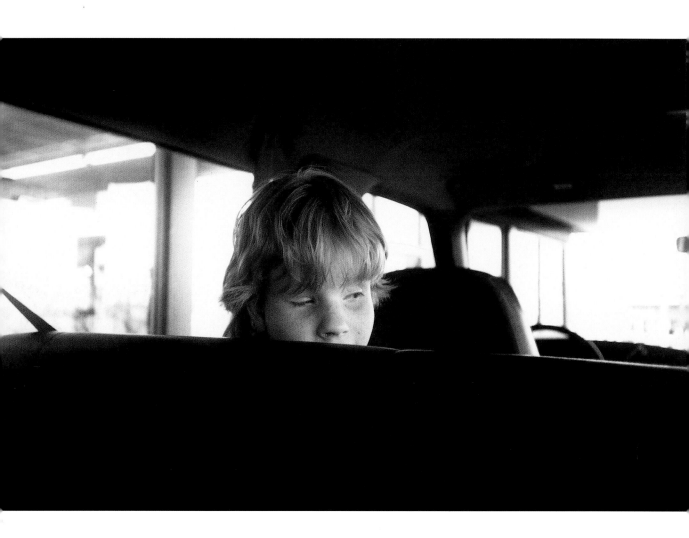

REBA | age 13 : Aulander, NC

▲
LOW VISION

afterword Learning Seeing and Beyond

by TONY DEIFELL, SHIRLEY HAND, and DAN PARTRIDGE

Our students called us by our last names—Mr. Deifell, Ms. Hand, Mr. Partridge, and Ms. Toal—a clear sign that teachers were typically not the students' peers at Governor Morehead School for the Blind. When it came to the photography class we named "Sound Shadows," we were on equal footing with our students in many ways. There were no curriculum guidelines, and none of us had ever taught photography to students who were blind or visually impaired, so we were learning along with our students.

Although we hadn't originally imagined a book, the students had envisioned showing their photographs to people outside the confines of the school. During one class, MELODY said, **"We can show other people that there is more to being blind or visually impaired than you think. We can do more than what you think we can do."** Little did our students know that their stories and images would also show us how much more there is to seeing, beyond eyesight.

The original aim of the Sound Shadows project was to support the educational needs of the students—and photography served mainly as a means to that end. During the first year, all we could manage to accomplish was figuring out how to teach the students to use cameras. As students began adding captions to their pictures, we realized that photography could support the reading and writing goals of the school's curriculum.

Students came to Governor Morehead from across North Carolina because their local schools could not meet all their needs. Many could not read or write but relied on verbal communication—not only because they were visually impaired, but also because many had learning disabilities and motor-control difficulties. Since the students' abilities varied so much, they had a wide range of visual and language arts skills that could be further developed through creative and flexible pedagogical approaches. **We discovered that students needed to progress at their own pace—not according to our rigid lesson plans.**

Students who participated in the Sound Shadows project learned how to do more than take pictures; through photography they gained literacy skills that were fundamental to their language arts education. Early in the project, we found that pictures provided a new way to create vocabulary flash cards that students could use with their parents and other sighted people. We would send students on a vocabulary scavenger hunt—they would take photos of things such as a stethoscope, a fire hydrant, a maple tree—and then emboss the words in Braille on the fronts of the pictures. As a result, these cards had two languages—a visual image for a sighted person and Braille for the student.

We also began linking picture taking with creative-writing assignments about topics such as dreams, fears, self-portraits, family, and vocations. Through these assignments, students learned to sequence stories and combine images and words. RICKY and ANTONIO documented the steps of making popcorn, for example.

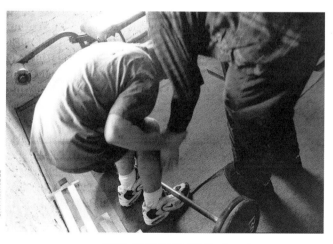

JOHN C. explained weightlifting through a sequence of photographs:

1. Stretch your muscles.
2. Choose a low weight.
3. Bend from the knees to pick up the bar.
4. Slowly straighten out the legs.
5. Flex.
6. Take a rest.

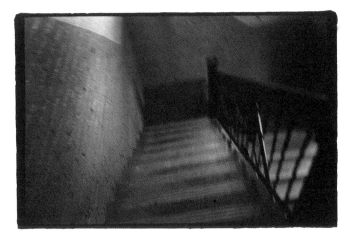

By using photographs to symbolize their ideas, some students developed an understanding of metaphors. **After a dream about wandering aimlessly in a snowstorm, JOSH made a photograph of dark, blurry stairs that reminded him of his dream.** He decided to use the picture to represent the feeling of being lost in his dream. TRAVIS used photography to draw comparisons between his hometown of Charlotte, North Carolina, and Los Angeles, California—where he had never been. TRAVIS had pale white skin but was convinced he was black. For his self-portrait assignment, which he called "the 'hood," he planned to tell a story about his "homies." "Aren't you from Charlotte?" we asked. "No I ain't," he said. "I'm from South Central L.A. I will take pictures of places that look just like that." For his research, TRAVIS interviewed a family friend who had lived in L.A., and his mother drove him around his own neighborhood to photograph the YMCA, the park, and his house. He loved having these photographs described to him and stapled them to pages of Braille text comparing each image with Los Angeles. He even created a musical sound track to supplement his report.

Students made books and worked to write captions themselves. When ANTONIO assembled his "Family Photo Album," he designed the book by selecting recycled Braille paper for mounting prints, deciding how to group the images, and writing captions. The students directed their own process, which gave them a chance to develop their creativity and critical expression.

Students with no vision or light perception often imprinted Braille captions on their pictures. These prints became more than four-by-six-inch pieces of paper; **they were transformed into meaningful physical objects.** Students used these prints to remember their images, to organize them with other images, and to choose which ones to show people—just as anyone would carry pictures of loved ones in their wallets. Though REBA was not totally blind, she also liked to write on her pictures. She developed her own visual style, cutting up the pictures to make collages. She produced a study of fashion at the school, as well as an exhibit of her favorite teachers, which also involved interviews. In one interview, she asked the principal, "Why do you make such strict rules?"

Sometimes photography allowed students to communicate their ideas much more easily than they could in writing—which became a useful step in learning to read and write better. Before arriving at Governor Morehead School, MERLETT was told that she would never be able to read. She was learning disabled as well as totally blind since birth. Ms. Hand had the job of teaching her Braille. Reading and writing were torture for MERLETT. **She had plenty of stories, though, and photography became her way of telling them.** After taking pictures, MERLETT would describe what she had shot, and words would come to her easily. Through oral history, MERLETT improved her writing ability and found her voice. As her trust in Ms. Hand grew, MERLETT became a brave and prolific photographer and storyteller.

• • •

As the Sound Shadows project evolved, we began to realize that photography offered additional benefits beyond the explicit goals of the school's language arts curriculum.

Several students could, in fact, literally see the world better by taking pictures. Even though some students were partially sighted, they often struggled to see the three-dimensional world because

of focusing problems, tunnel vision, and other challenges. Two-dimensional photographs capture a broad view of a scene in one, small place. Students could hold these images close to their eyes, magnify them, or hold them in the best light. At the same time, photographs provide both a wide perspective and detail. As George Covington, a well-known photographer who was born legally blind, puts it, **"Most people see to photograph; I photograph to see."**

Most students had never taken a picture before the Sound Shadows project. FRANCES didn't think she could do it, but her mom encouraged her. "She said to go for it and see what happened," FRANCES recalled. "Like, they told me I couldn't play girls' basketball in public school, but I did." JOSH's mom wrote in a parental questionnaire that photography "is important to our son because it has allowed him to participate in an activity that ordinarily would not be offered to a person with visual impairment."

We assigned each student a camera of his or her own for the semester. Although we initially worried that we might never get the cameras back, trusting the students to keep the cameras safe came with some unanticipated pluses. ANTONIO's mother explained that it had helped her son learn greater responsibility. "I love the fact that he takes care of his camera," she wrote. We made project-based assignments that often required many weeks of work; KATY's mother noted that this program "gives them a sense of achieving a goal."

Many of our assignments required collaboration and teamwork. JOHN C. wanted to photograph a dream—one in which he was being chased by a flying ten-pound, stainless-steel Braille Writer. The whole class collaborated to stage the picture taking, which began with adding googly eyes and Styrofoam-peanut ears to make the Braille Writer come alive. **People often think that people who are blind develop a superhuman sense of hearing to compensate for the lack of eyesight,** but our students could be just as distracted as any teenager—a mix of voices, music, and other sounds constantly called for their attention. During a very elaborate process

of rearranging furniture and acting out JOHN's dream, the students learned to listen to each other and work together to create all their shots.

Since photography was a fun way for students to learn, it helped them *want* to engage in school. JOHN V. was known for playing hooky and getting in trouble. When he started learning photography, he stopped skipping class, and other teachers noticed his renewed interest in learning. TRAVIS often walked into class with a chip on his shoulder. He didn't want to be there. TRAVIS believed that he was smarter than his classmates and constantly called them "retards." The truth is that TRAVIS was insecure and physically fragile—heart failure took his life when he was only seventeen. When Mr. Partridge told TRAVIS he could do a self-portrait, TRAVIS couldn't contain his excitement and started creating his project about South Central Los Angeles. **Photography made him forget about being angry for a while.** He began to get along with classmates better, and he would finish his other homework without complaining, if it meant he could work with Mr. Partridge on his photography project.

If many of the students were reluctant learners, they were even more reluctant photographers at first. As they succeeded at taking pictures, their self-confidence grew. At the end of MERLETT's first year of photography, she admitted to Mr. Deifell: "I don't know if I want to take photography next year. I mean, I'm not trying to put you down or nothin'. I mean, it's not hard, I just don't know if I want to take it." MERLETT had very little confidence. School was a difficult, demeaning place for her—classmates made fun of her all the time, and she struggled so much with reading and writing. Using the camera was fun, it didn't require reading, and it enabled her to tap her storytelling talents. By saying that *she didn't know if she wanted to take photography again,* MERLETT protected herself from disappointment. If photography wasn't important to her, no one could take it away. By the end of her second year in the class, MERLETT's confidence had grown. She finished twenty-four rolls of film—more than any other student throughout the project.

Students would choose projects in order to teach classmates their favorite activities—how to fry bologna, how to play the "Super Mario Brothers" computer game, or how to use the camera. **Students had previously seen themselves only as learners, so teaching others was an empowering experience.**

JOSH's mother told us, "Photography has encouraged my son to explore his environment by trying to look for things to photograph." Students learned how to interact with people and places by taking pictures. When MERLETT chose to document the maintenance workers on campus, she had to plan ahead. "I had to call down to maintenance to see if I could take pictures," she said. She set an appointment to gather information about the crew, the types of work they did, and what times they were available to be photographed. After creating a plan, she executed photography shoots and produced a book.

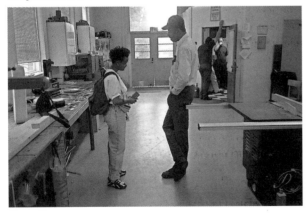

MERLETT interviews a groundskeeper

Photography provided students with firsthand experiences that were normally unavailable to them and sometimes beyond the reach of most people with sight. Like many of our students, CHRIS spent his free time listening to the radio. He wanted to learn more about it—which he could have done simply by interviewing a disc jockey by phone. Photography required a field trip, which enabled him to interact directly with the disc jockeys and to explore an unfamiliar environment. To take pictures, he had to ask about everything in the production and broadcast studios, explore the space with his hands, and decide which parts were most important to capture on film. Afterward, his pictures helped to remind CHRIS of what he had learned about such details as the music library, the soundboard, and other recording equipment. This photography field trip also showed CHRIS that he could conceive of a project and make it happen. He later initiated—on his own—a photography project about a tire shop. Students often chose to take photography field trips, which also allowed them to explore their vocational interests. RHONDA photographed a kindergarten classroom to explore her interest in teaching. JACKIE learned about health professions through a hospital field trip.

The Sound Shadows project was a field trip for all of us—a voyage of learning and seeing. Photography was the unlikely vehicle that brought creative communication, critical thinking, and courage both to our students and to us. **The students were not learning to see; they were "learning seeing"—a process that requires all human faculties.** By teaching them photography, we were *learning seeing* ourselves.

Where Are the Students Now?

Nearly ten years after the project, all of our students have graduated. Mr. Deifell traveled across North Carolina in summer 2005 to visit some of them with filmmaker Bryan Donnell, who documented the journey. They learned what many of the students are doing today, although they couldn't find some of the students who had moved after graduating.

REBA DREW
photo by MERLETT

EYESIGHT: "If I looked at you, I'd have a black spot in the middle but could see on the sides. I can read regular-sized print in a magazine, but I just have to tilt my head."

2005: REBA wrote a book that she calls "Life's Lessons"—a thirty-two-chapter, eighty-seven-page book about her school days that she likens to *Dawson's Creek*. She became engaged to RICKY after graduation but returned the ring when the relationship didn't work out. *(Also pictured on pp. 68, 94, 95, 98, and 104.)*

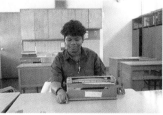

LEUWYNDA FORBES
photo by MERLETT

EYESIGHT: "Have you ever stood outside and the sun was behind the person you're looking at, so all you could see was a shadow—no face, no eyes, no mouth—that's what I see. It's like a tunnel, and I can't see far away."

2005: LEUWYNDA lives in her own apartment in Florida and works at Food Lion grocery, where she can bring in as many as five shopping carts at once—which, she explains, is quite a feat since cerebral palsy causes her to feel out of balance. *(Also pictured on p. 54.)*

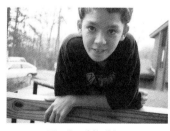

RICKY WESTBROOK
photo by KATY

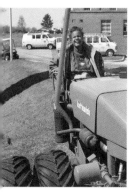

MERLETT LOWERY
photo by teacher

EYESIGHT: No vision.

2005: MERLETT lives in an apartment by herself and loves listening to her favorite R & B musician, R. Kelly. She calls her best friend, REBA, by cell phone almost every day and still tells stories. *(Also pictured on pp. 94, 95, 104, and 144.)*

EYESIGHT: "I'm just blind in one eye, I can't hardly see anything. But my right eye sees just as good as you."

2005: RICKY is still friends with REBA and attended her twenty-third birthday party with his family in summer 2005. He works at his brother's gas station and says that becoming a father has changed his life. *(Also pictured on p. 113.)*

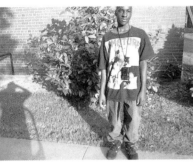

ANTONIO WILLIAMS
photo by KATY

EYESIGHT: "I see pretty well. When I'm reading, that's the problem. On the computer, I have to make it eighteen-point."
2005: ANTONIO lives forty minutes from his many aunts and cousins but has his own son to look after now, whom he's nicknamed "Mr. Fatso." ANTONIO works at Wal-Mart. *(Also pictured on p. 80.)*

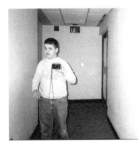

ANTONIO
photo by ANTONIO

BRYAN McKINNISH
photo by ANTONIO

EYESIGHT: No vision.
2005: BRYAN is still into gadgets; he recently got his own laptop and likes to program his own video games. He lives in his childhood home, which his mother plans to give him, and he hopes CASSIE might one day join him there. *(Also pictured on p. 84.)*

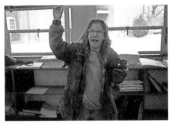

CASSIE KNIGHT
photo by CASSIE's mom

EYESIGHT: No vision.
2005: CASSIE finished a job-placement program at Governor Morehead School, where she learned to be a receptionist. She has taught herself to dance the tarantella, and dreams of going to Italy one day.

MELODY HEATH
photo by FRANCES

EYESIGHT: "I can see stuff, but I can't focus. I can't see out of my right eye at all."
2005: Melody received a guide dog in fall 2005 after losing most of her remaining sight. She plans to graduate from Guilford Tech Community College in 2006 and pursue a bachelor's degree in toy design. She has a four-year-old daughter, also visually impaired, whom she named Arianna because it means "from the most holy." *(Also pictured on p. 91.)*

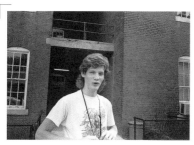

JOHN VIEREGGE
photo by BILLY

EYESIGHT: "I can't see facial features, but I can still program a VCR because it's got one-inch letters on a blue background—but it takes a while. I can't see at all in my right eye. I hate to think that I'm losing any more eyesight, but that's what's happening."

2005: JOHN was married two years after graduation. He works at Lion's Industries for the Blind with his wife and wants to own a house, "so I can paint it whenever I want." He dreams of owning an apartment complex one day or working in photography again. *(Also pictured on p. 79.)*

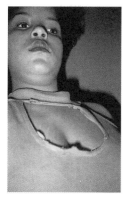

TAMEKA FARLEY
self-portrait

EYESIGHT: "I can see shadows but not colors very well. I can only read print if it is really, really big. I used to bring my pictures home for Mom to tell me about."

2005: TAMEKA likes to watch cartoon movies with her eight-year-old son, Noah, and six-year-old daughter, Angela. They all live with TAMEKA's mom but are getting ready to move to their own house.

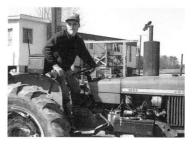

DAIN MURPHY
photo by DAIN's parent

EYESIGHT: No vision.

2005: DAIN works with his parents, farming fifty acres of soybeans in eastern North Carolina. *(Also pictured on pp. 53 and 78.)*

CHRIS SANFORD
photo by KATY

EYESIGHT: No vision.

2005: CHRIS lives at home, became a born-again Christian, and regularly attends the South Henderson Pentecostal Holiness Church. *(Also pictured on pp. 27, 55, and 59.)*

KATY SINGHAS
self-portrait

EYESIGHT: "In school, I saw in both eyes a little, but it has gotten worse. I can only see shadow and light in my right eye."
2005: KATY moved to Georgia with her parents, got her own house, and works for Goodwill Industries tagging clothes.

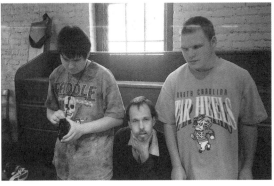

TRAVIS, DAN PARTRIDGE (teacher), JOHN C. *(left to right)*

TRAVIS LUCAS

EYESIGHT: No vision.
2005: TRAVIS's love for hip-hop music grew—much to his parents' dismay—and he became quite good at playing the drums. Although TRAVIS dreamed of going to Los Angeles, he never made it there; he died of a rare heart condition on the day after Thanksgiving when he was seventeen years old. *(Also pictured on p. 92.)*

JOHN CHERRY

EYESIGHT: No vision.
2005: JOHN's older brother, Jason, says that he still lifts weights because of JOHN—Jason didn't want to lose fights to his younger brother, so he asked JOHN to teach him weightlifting. JOHN passed away at age twenty-three of acute respiratory failure after battling Batten disease.

Thirty-six students ranging in age from twelve to nineteen participated in the photography class. Others in the class included JUNIOR BENTON, DESMOND BREWINGTON, NIVEA BRYANT, JOSH GRIFFIN, PAM GUPTON *(pp. 64 and 96)*, BRIAN LEWIS, JACKIE LITTLE, JONATHAN McCOLLUM, DeANGELO McMORRIS, JON PATTERSON, NICOLE PETERSON, TRACEY RATLEY, WILLIAM ROGERS *(pp. 59 and 86)*, CAREY SESSOMS, WENDY SHARPE *(p. 31)*, JESSICA SHUMAKER, DEAN SMITH, GILBERT THOMAS, FRANCES WARD *(p. 69)*, BILLY WOLF *(p. 95)*, and RHONDA WOODY.

Questions + Answers

When we tell people about the Sound Shadows project, they are often full of questions. For example:

How did we teach photography to students who are visually impaired?

Many of the students couldn't perceive light, but all of them could feel the heat it produced, and they understood how the sun works. We would describe how the camera's button opens the shutter long enough for light to burn an image onto the surface of the film. We also used the metaphor of sound recording, since music was such a big part of every student's world. We told them that light waves travel through the air and bounce off surfaces, just as sound does. The challenge of learning about the visual world of photography was eased by the students' ability to draw on a familiar realm of expression. For some vocabulary assignments, we used photographic terms, such as *lens*, *shutter*, *light meter*, and *aperture*. A particularly helpful word—*compose*—allowed us to explain how photography used some of the same principles as music or writing.

Students often wanted their pictures to be in color, and some students would try to identify images by the colors in them. But we mostly shot black-and-white film so that the students could learn to develop their own photographs. Since this process is primarily done in total darkness, the students had an advantage over sighted students, who often have trouble loading film on reels without being able to rely on their eyesight.

How did we describe students' photographs to them?

When we asked our students why people who are blind should learn photography, FRANCES offered, "'Cause it'd give students a chance to see what things are like, have people describe things to them so they'll know what's around them." We invited guests to the school to mentor the students or to describe their pictures to them so that they could hear different perspectives. We audiotaped some sessions, parts of which are included in the book.

Describing pictures was a critical part of teaching photography, and it was quite difficult to do. Students constantly challenged us to do a better job explaining what we saw. After being told that a picture had "fluorescent lights up at the top," JOHN V. responded, "Okay, I thought every building had fluorescent lights." Occasionally the process was simply a guessing game, as students tried to figure out which moment they had captured on film. Other times, we found better analogies to describe images, for example, describing a picture of a flash bouncing off a television screen as looking like "the center of the universe."

Were the students totally blind?

Most people who are blind have some remaining vision. One-third of our students could see their pictures in varying degrees by holding them close or by enlarging them. The students varied in their ability to focus; to perceive depth; and to see light, shadow, and movement. Some had tunnel vision, while others had only peripheral vision. Two-thirds of our students had been limited to using nonvisual media such as Braille, which usually meant that they depended on someone to describe their pictures. We attribute three

broad categories of visual ability to the photographers throughout the book, which should be supplemented by their own descriptions on pages 145–148: NO VISION means totally blind. LIGHT PERCEPTION means a student has little usable vision and relies mainly on other senses. LOW VISION indicates some useful sight, reaching at best 20/70 after correction with glasses.

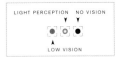

Have the students continued with photography?

"I loved that camera!" JOHN V. said in 2005, recalling that his camera was stolen at school thirteen years earlier and wishing he could get back into photography. During the project, JOSH's mom wrote: "JOSH has asked for a camera for his birthday." LEUWYNDA has her own camera now and still likes photographing friends and dogs. By now some of the students have taken up digital cameras, while others, such as REBA, prefer using a video camera. Most of the students have left photography behind, since their lives have gone in different directions. DAIN still remembers the details of almost every picture he took in the class, but he hasn't used a camera since he graduated. He prefers audiotapes. DAIN explained that a friend records the sound of truck engines in a repair shop so that, during the winter when it is too cold to work outside on his farm, DAIN can listen to the recordings. He diagnoses engine problems relying only on what he can hear. "Those tapes are my pictures," he explained.

Are there other photographers who are blind?

When we taught photography from 1992 to 1997, we didn't know of any other similar programs that worked with people who are blind and visually impaired. As this book was being published, we learned of some. In Prague, Daniela Hornickova worked with blind students at the Jaroslav Jezek Boarding School from 1993 to 1995. At the Texas School for the Blind and Visually Impaired, Carrell Grigsby taught photography to help low-vision students optimize their remaining vision. Mark Andres and the Seeing with Photography Collective in New York City published *Shooting Blind* (2002)—a book of photographs taken by adults who are blind. In addition to Henry Butler, Evgen Bavcar, and George Covington—mentioned earlier in the book—many other working photographers are visually impaired, including John Dugdale, Flo Fox, Pedro Helgado, Michael Richard, and Alice Wingwall. In fact, many famous visual artists continued to work with varying degrees of success after becoming visually impaired, among them Mary Cassatt, Honoré Daumier, Edgar Degas, Claude Monet, Edvard Munch, and Georgia O'Keeffe. Degas and Munch even took up photography later in their careers, partly because of their failing eyesight.

Who taught the class?

Tony Deifell first called the Governor Morehead School in 1992, shortly after graduating from the University of North Carolina at Chapel Hill in anthropology. He was twice named college photographer of the year in the state, yet he nearly failed a photography class because he spent all his time starting the APPLES service-learning program at the university. He now lives in San Francisco, where he works at the intersection of media and social enterprise.

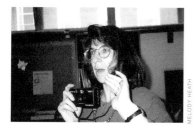

Shirley Hand came to the Governor Morehead School in 1994 to teach English and was recruited to help develop the Sound Shadows project. She started working with visually impaired children in the summer of 1970 at the New Jersey Camp for Blind Children, where she was moved by her students' arts projects. Before settling in North Carolina, she taught for fourteen years at New Jersey Commission for the Blind and Visually Impaired. She now teaches preschool at Governor Morehead.

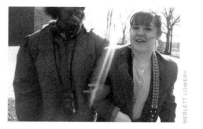

Jessica Toal joined the project in 1994, participating for a year in conjunction with the AmeriCorps-funded program Public Allies. Having recently graduated from high school, she was just a year older than some of her photography students, so she became fast friends with them. She now lives in Los Angeles.

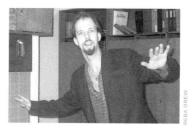

Dan Partridge arrived in 1995 to help teach the class for two years. He had recently graduated from the University of North Carolina at Chapel Hill with a degree in English and art history. As a disc jockey for the student station WXYC, he shared an affinity for radio and music with the students. He now works at the Center for Documentary Studies at Duke University on a project focusing on W. Eugene Smith's photographs and recordings made in his New York City loft building in the late 1950s and early 1960s. *(Also pictured on pp. 27 and 148.)*

For answers to other questions, additional information, more photographs, and online discussion, please visit **www. seeingbeyondsight.com.**

acknowledgments

This book would not exist without a few people who could see beyond what already exists to what was possible. Joan Baker and Sheila Breitweiser took a risk to support the initial idea. Shirley Hand, Dan Partridge, and Jessica Toal brought new dimensions to teaching the class. Bubba White and J.W. Photo Labs stuck with the project all five years, tallying quite an in-kind contribution. Designer Julia Flagg has shared in the vision for this book since 2000 and was the main reason I found a publisher without a literary agent. Chronicle Books has a wonderfully appropriate slogan—*we see things differently*—and my editor Alan Rapp supported the unusual vision for this book at every turn. My dear friend Bryan Donnell has given countless hours of feedback on the book, and he is directing a film about the project. Mardie Oakes and I are not only life partners, but also creative partners. Her collaboration was integral to this book. And, lastly, my family—Jey, Joan, David, Elizabeth, Heather, and Hope—has given me undying support. Risks don't seem so risky with such love.

Many other people have contributed to this project since 1992, and their generous support has also been critical along the journey. Fay Agar, Bill Apple, Fred Baars, Cyndie Bennett, Julie Burton, Keri Lohmeier, Fred McEachern, Peggy McSwain, Judy Plymale, Dennis Thurman, Carolyne Tucker, Jane Young, Wanda Williams, and everyone at Governor Morehead School. Alex Byrd, Soyini Madison, and Julia Scatliff O'Grady for reviewing our students' pictures with them (see text on pp. 14, 30, and 34). Holly Blake, Kathryn Reasoner, Linda Samuels, and the staff and artists at the Headlands Center for the Arts. Justin Jacobs, Linda Hughes, Miranda Caroligne, and everyone at Red Ink Studios. Robert Coles for his generous foreword, Iris Davis for her printing, Beth Dungan for her knowledge at the intersection of art and health and for helping curate an exhibit. Jane Anne Staw, Laura Fraser, and Wendy Lichtman for being writing coaches, and Doris Betts, David and Elizabeth Deifell, Steven Moss, Mary Scholl, and Daisy Wademan for extensive reviews of early drafts. Kristen Grimm and Spitfire Strategies for supporting outreach. Loren Kwan, Juliana Triadafilopoulos, and Jomar Giner for interning.

Advisors on visual-impairment themes: Yvonne Howze, Georgina Kleege, Michael Marmor, Benjamin Mayer-Foulkes, Jim Fruchterman, Scott Nelson, Kari Orvik, Jen Potter, Katherine Sherwood, Bill Tasman, and Vicki Vogt. Advisors in the art and photography worlds: Charlotte Vestal Brown, Kimberly Camp, Roger Manley, Linda McGloin, Holly Morrison, Michael Richard, Emily Todd, and Julie Winokur. Will Berkovitz, Matthew Brown, Arrington Chambliss, Jey Deifell, Claudia Horwitz, Leng Lim, Hung Nguyen, and Rachel Ravitz for helping me see the spiritual undertones of this work.

For contributing to community-editing sessions: Sally Aaron, Laylah Ali, Jessica Brooks, Chris Gallagher, Marilyn Donahue, Michael Echenberg, Stephanie Federico, Daren Firestone, Ron Fouts, Nicole Hanrahan, Brian Harnetty, Marjorie Hudson, Brenda Hutchinson, Rupert Jenkins, Robin Lewis, Natasha Garcia Lomas, Trevor McCaw, Leigh Morgan, Christine Neer, Hahva Neff, Russ Neufeld, Ben Plowman, Lelach Rave, Elana Rosen, Meghan Stern, and Maura Wolf.

The staff and board of the Institute for Public Media Arts, including Alison Byrne Fields, Malkia Lydia, Kelly Overton, Edgar Beckham, José Calderón, Mary Childers, Gwen Dungy, Betsy Fenhagen, Kristen Grimm, Linda Holtzman, Amira Leifer, Caryn Musil, Nayo Watkins, and Amie Weinberg.

Other advisors and supporters: Jeanne Argoff, Isisara Bey, Keith Hammonds, Lisa Halliday, Brooke Johnson, Dutch Leonard, Richard and Jennifer Linder, Bernadette McCann, Deborah Meehan, Karen Moore, Jim Morgan, Melvin and Patricia Oakes, Bridget Watson Payne, Jim Pitofsky, Ellen Schneider, Taz Tagore, Nina Utne, and the Omidyar.net community. Darell Hammond, Kate Becker, Carrie Suhr and KaBOOM!. Bill Bamberger, Iris Tillman Hill and the Center for Documentary Studies at Duke University.

Reba Drew for helping me track down her classmates. And, finally, to all the students and their parents for taking a chance on this project.

When you see, you'll find out.

—ANTONIO